Exploring Society Photographically

Exploring Society Photographically is published to accompany an exhibition of the same title on view at the Mary and Leigh Block Gallery, October 16 through November 29, 1981.

© Copyright 1981, Mary and Leigh Block Gallery, Northwestern University

Library of Congress Catalogue Card Number: 81– 83668

ISBN 0-941680-00-2

Exploring Society Photographically is distributed by The University of Chicago Press

Printed in the United States of America
Printer: Congress Printing Company
Design: Hayward Blake & Company
Composition: Automated Office Systems, Inc.

Exploring Society Photographically is supported by funds from Northwestern University, the Mary and Leigh Block Gallery Friends of Art, a grant from the Illinois Arts Council, a State agency, and a grant from the National Endowment for the Arts, a Federal agency.

Balinese Character: A Photographic Analysis, Gregory Bateson and Margaret Mead, copyright 1942, The New York Academy of Sciences. Material from *Balinese Character* used with the permission of The New York Academy of Sciences. *Gardens of War,* Robert Gardner and Karl G. Heider, copyright 1968, The Film Study Center, Peabody Museum, Harvard University. Photographs by Frank Cancian used with his permission. Photographs by John Collier Jr. used with his permission. *Killing Time: Life in the Arkansas Penitentiary,* Bruce Jackson, copyright 1977, Cornell University Press, used with the permission of Cornell University Press and Bruce Jackson. Photographs by Douglas A. Harper are taken from *Good Company: A Tramp Life* by Douglas A. Harper, to be published in Spring 1982 by The University of Chicago Press, © 1981 by Douglas A. Harper. All rights reserved. The text for ''Selections from the Road'' is excerpted from *Good Company: A Tramp Life* by Douglas A. Harper, to be published in Spring 1982 by The University of Chicago Press. © 1981 by The University of Chicago. All rights reserved. Photographs by Karin B. Ohrn used with her permission. Text by Richard Horwitz used with his permission. Photographs by Bill Aron used with his permission. Material from *PATIENTS: The Experience of Illness,* Mark L. Rosenberg, MD, reproduced with the kind permission of The Saunders Press, Philadelphia, copyright 1980 by W. B. Saunders Company. Photographs by Euan Duff used with his permission. Photographs by Charles Berger used with his permission.

Cover illustrations: Details from *Balinese Character: A Photographic Analysis* by Gregory Bateson and Margaret Mead.

Exploring Society Photographically

Howard S. Becker

Department of Sociology
Northwestern University

Mary and Leigh Block Gallery
Northwestern University
Evanston, Illinois

Contents

Foreword

The idea of organizing an exhibition devoted to the photographic work of visual sociologists and anthropologists was first presented to me by Howard Becker, Professor of Sociology, in fall 1979. I spent time becoming familiar with the material and quickly learned that the world of the social scientist, particularly when photography is the research tool, is indeed most fascinating. *Exploring Society Photographically* thus developed and Professor Becker began his search for significant scientific, artistic, and cultural projects to include in the exhibition and in this publication.

Kathy Kelsey Foley
Director,
Mary and Leigh Block Gallery

We selected twelve projects, representing a wide range of both scientific research and photographic styles. A selection of images from each project included in the exhibition is reproduced here. Margaret Mead and Gregory Bateson's monumental study, *Balinese Character,* serves, in a sense, as a precursor to the in-depth studies of primitive cultures and societies undertaken by Robert Gardner and Karl Heider for Harvard University's Film Study Center, Frank Cancian, and Eduardo B. Viveiros de Castro. Bruce Jackson examines life in an Arkansas penitentiary and Douglas Harper rides the rails with migrant fruit pickers. The "strip" is the subject of Karin Ohrn and Richard Horwitz's study; a "state-of-the-art" McDonald's is compared and contrasted to a family-run operation, Diamond Mil's. A Boston physician, Mark Rosenberg, examines patients with his camera and through conversation; he puts his stethoscope aside to offer a penetrating view of the experience of illness. A *Flamenco* performer is captured by Charles Berger's camera and transformed via an unusual color process. The urban assimilation of American Indians is the subject of John Collier Jr.'s work and Euan Duff's photographs of various work experiences reveal his views of contemporary society. Bill Aron focuses on two unique worlds in Venice, California; sensitive pairings of images explore the lives of elderly Jews and the roller-skating cult. To these social scientists and photographers I express our deep gratitude for their participation and cooperation. We have enjoyed aesthetic pleasure and our knowledge of the world within which we live is broadened because they have shared their work with us.

The credit due Howard Becker is immeasurable. He has fulfilled his role as guest curator of *Exploring Society Photographically* with extreme professionalism and style. I gratefully acknowledge his suggestion of the exhibition itself, the many dedicated hours of work, and his insightful writing and preparation of this publication. The staff of the Block Gallery has been invaluable throughout the organization of *Exploring Society Photographically.* The contributions of Karl Snoblin, registrar and preparator, and Miriam Littell, department assistant, are evident in the exhibition and in the pages that follow. Finally, this project would not have been possible without grants awarded by the National Endowment for the Arts and the Illinois Arts Council and generous funds provided by the Mary and Leigh Block Gallery Friends of Art. ◇

Introduction

Howard S. Becker

Exploring Society Photographically investigates some of the many efforts made by photographers and social scientists to combine the two disciplines and perspectives, to use visual means to understand the workings of the social world. Its premise is that this well established enterprise has suffered from a variety of unnecessary difficulties. Its hope is to demonstrate, through the work of a number of practitioners of differing professional backgrounds and experience, how the difficulties can be overcome and what the possibilities are. At best, the pieces might serve as exemplars, as models and points of departure for further explorations made by a new generation for whom what now seem to be problems and contradictions will have disappeared.

We customarily distinguish between science (including social science) and art, seeing the one as the discovery of the truth about the world and the other as the aesthetic expression of someone's unique vision. All very well, except that so many artists' visions are of the truth about the world, and scientists' discoveries of that truth contain so strong an element of personal vision. The two enterprises are confounded in ways that cannot be unmixed. However uneasy that might make everyone involved, we need to treat them as complementary rather than opposed.

The elements of overlap and continuity between the aims of social science and art are, in the case of photography, particularly obvious. Photographers have, from the beginning, made it their business to photograph the social world, whether because of an interest in far-off places and exotic peoples, or in order to report on exotic events and people closer to home. Social scientists have, from time to time, photographed the people and places involved in their research (though seldom as a routine matter, except in the case of anthropology). Photographers have studied anthropology and sociology and social scientists have studied photography.

Both groups seem a little uneasy about these overlaps and continuities, as though the two aims—social analysis and aesthetic expression—were necessarily contradictory, as though you could only satisfy one at the expense of the other. The obligations a work has by virtue of its status as art seem to require adherence to conventions characteristic of the world of visual art. For instance, a work ought to be "original" in some sense, a unique drawing or painting, or one of a limited edition of works made by the recognized means of producing such editions. The obligations of science require adherence to such conventions as the explicit presentation of hypotheses and conclusions and the objective

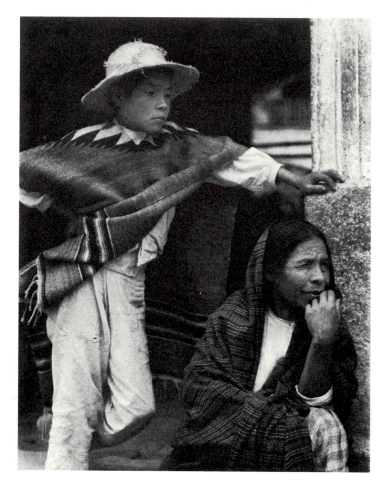

Paul Strand, "Woman and Boy, Temancingo," 1933, gravure from *The Mexican Portfolio*. Reproduction courtesy of Special Collections, Northwestern University Library.

assessment of evidence. The way social scientists distribute their work makes it unlikely that they will want to make unique objects, and the stylistic tendency toward allusion and understatement characteristic of much art makes explicit analysis seem gauche. Workers in the documentary genre experience these contradictions as personal dilemmas.

Take, as a simple example, the question of format. The "natural" format for social science photography seems to be the book, reproduced in large quantities and in no way a unique object, in which the work appears as a large collection of photographs accompanied by a substantial analytic text. Similarly, the "natural" format for art photography seems to be a gallery wall, hung with a collection of chastely matted and framed individual original prints, each treated as complete in itself, none requiring verbal explanation. Classic examples might be the Mead-Bateson collaboration *Balinese Character,* which barely makes sense as anything other than a book, despite the great beauty of some of the individual photographs, and Paul Strand's *The Mexican Portfolio,* the integrity of which would seem to be violated by any ethnographic information one might zealously append.

But the classical formats are needlessly constraining. Social scientists who make photographs need not be as heedless of their artistic strength as Margaret Mead and Gregory Bateson were. Mead herself feared that the urge to make art would interfere with the objectivity science required (although Bateson understood that the stylistic nullity that constituted the objectivity she had in mind was neither possible nor desirable). Many scientists fight the urge to be artful, and manage to be conventional in their mode of presentation. Some may come to see, however, that there is more than one way to let others participate vicariously in the processes of data gathering and reasoning which lead the social scientist to results. They may recognize that ostentatiously labeling an idea "hypothesis" does not make it a better idea, and that unconventional modes of presentation which use the resources typically associated with art may be well suited to the purposes of science.

Similarly, art photographers (and the social scientists who, overcoming their urge to be scientific, imitate classical photographic formats) can use the resources that contemporary art, so oriented to the idea of *information,* makes available. Conceptual art, particularly, has freed photographers from the classic requirements of a finely-made print of a single image as an end in itself. As a result, artists have begun to explore new ways of presenting information; in the case of art aimed at exploring society it might just as

well be social science information. These new formats are well adapted to the presentation of scientific ideas and results, even though they may not do that in the classical way. Artists attempting to maximize the amount of information they convey may use multiple images, large amounts of raw data as text, the language of a highly "objective" science, the manipulation of color characteristic of a more expressionist art, or unconventional combinations of any number of such devices. Doing that, they may (and probably will) manage to offend both scientific and photographic purists. I think here of the work, in graphics rather than in photography, of Hans Haacke, who has merged the requirements of art and the scientific study of power structures in such a way as, for purists, to violate the canons of both science and art and, for those who are more open-minded, to achieve something quite admirable in both departments.*

The photographers represented here cover the full range of possibilities. Some are more concerned with the presentation of evidence than others. Some use conventional forms of artistic presentation; some have chosen instead to violate the conventional integrity of the single print. Some use text in larger quantities than others. They all leave us knowing more about some aspect of a society than we did before we absorbed their work. They all leave us with the thrill of appreciating a fresh vision. In this way they satisfy our demands for what both science and art can give and suggest that the dichotomy and contradictions I have discussed are only conventional and need not detain anyone seriously interested in understanding society and making art at the same time.

What all this work shares, and one of the sources of its strength, is the deep and intimate acquaintance of the people who made the images with the people and places they photographed. By spending long periods of time among the people in the societies they studied, these photographers learned what was worth photographing, where the underlying rather than superficial drama was, how that drama might be put into the language of volume and light most effectively. You cannot learn that in a week or two, and that is the essential difference between journalism and the explorations of society presented here. Society reveals itself to people who watch it attentively for a long time, not to the quick glance of a passerby. Though the photographers have chosen very different ways of giving physical form to the understanding so gained, they have all invested their time and selves on a massive scale to achieve it. ◇

* See Hans Haacke, *Framing and Being Framed: 7 Works, 1970–75* (Halifax: Press of Nova Scotia College of Art and Design, 1976).

Balinese Character:
A Photographic Analysis
By Gregory Bateson and Margaret Mead

Howard S. Becker

Gregory Bateson and Margaret Mead did field work in Bali at various times between 1936 and 1939. They were both concerned with the study of culture as a system of understandings and behavior and, simultaneously, as an expression of personal experience and character. Both had attempted to deal with the connections between those two things in their earlier work, and both were dissatisfied with the results. Looking for a better way, they decided to use still photographs and moving pictures to study culture as embodied in the intimate details of behavior. They presented their results in what is still the most ambitious work of anthropological photography ever published, *Balinese Character*.

They were clear about their aims: "This is not a book about Balinese custom, but about the Balinese—about the way in which they, as living persons, moving, standing, eating, sleeping, dancing and going into trance, embody that abstraction which (after we have abstracted it) we call culture." They made some 25,000 35 millimeter exposures in addition to shooting 22,000 feet of movie film. Bateson made the photographs and Mead accompanied him, making voluminous notes on every frame of who the subjects were and what they were doing and saying. The question then arose, how were they to present such a mass of visual material?

The most conventional part of the book, published in 1942 by The New York Academy of Sciences and long out of print, is Margaret Mead's 48 page essay in psychological anthropology, relating characteristic features of Balinese child rearing patterns to characteristic emotional states and cultural emphases. The remainder of the book is, as they say, "an experimental innovation":

"In this book we are attempting a new method of stating the intangible relationships among different types of culturally standardized behavior by placing side by side mutually relevant photographs. Pieces of behavior, spatially and contextually separated. . . may all be relevant to a single discussion . . .By the use of photographs, the wholeness of each piece of behavior can be preserved, while the special cross-referencing desired can be obtained by placing the series of photographs on the same page."

The book contains 759 photographs, arranged in 100 "plates", each containing from six to eleven individual images. Each plate has, on the facing page, a short analytic remark by Bateson and quotations from Mead's detailed on-the-spot notes.

Many of the photographs are remarkable images in their own right. Consider the photograph from "The Surface of the Body", described as "Women lousing at a wedding". The picture might have been made by Henri Cartier-Bresson. But if it had, it would have appeared as Cartier-Bresson's pictures typically appeared, as a discrete image, perhaps embedded in a series about Bali or Southeast Asia, or just in a collection of his best work. The Bateson photograph has the visual vitality and complexity we associate with the work of fine art photographers: the composition leads from one lively and characteristic face to another, the visual busyness complementing the busy fingers of the women as they pick through one another's hair.

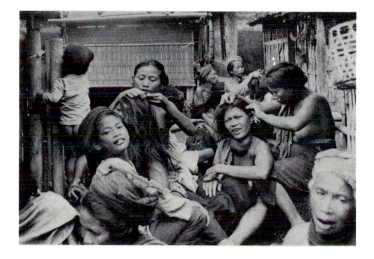

But the photograph, by virtue of the sequence in which it appears and the place of that sequence in the larger sequence that makes up the book, has more meaning than an isolated image can have. It becomes part of the evidence for and an illustration of a complicated theory about the kinds of stimuli Balinese look for and respond to. That theory has an aesthetic appeal of its own, a neat and satisfying completeness that, in turn, deepens the meanings of the individual image and gives us a richer intellectual and aesthetic experience.

The format of the book is, at first, forbiddingly "scientific". But, as it becomes more familiar, the format becomes the means for creating, in a systematic way, the context Bateson and Mead thought necessary for the understanding of individual bits of behavior. It gives those bits an interest they would not otherwise have and gives to the best images multiple meanings which improve them.

The book embodies the dilemma alluded to earlier. If a body of photographic work really requires a book format and substantial text, can it achieve its full effectiveness on the walls of a gallery or in full page reproductions of single images? On the other hand, when so many of the images have all the qualities of the photographs we ordinarily admire when so presented and have in addition the richness provided by the fuller context of a book, why not look at them as we usually do the single images of art? The actual prints and negatives made by Bateson and Mead in Bali are not presently available; if they were, the temptation to pick out the most compelling images and present them in a conventional way would be strong. Since they were not available, it seemed best to treat the work as an important historical precursor of the later work whose problems and possibilities it so clearly foreshadows.

Pages from *Balinese Character* give some sense of the striking images it contains and, to a lesser extent, of the synergy that arises from the multiple imagery. ◇

Plate 80

FEMALE CHILDHOOD

During the period between early childhood and adolescence, girls have a very definite part in the social life of the village. In addition to the care of babies, already illustrated, the girls do a considerable part of the work of preparing offerings for temple feasts and ceremonies in the household; they carry the offerings to the temple and remain there as an important part of the congregation. In fact, the business of ritual is carried on chiefly by older people and girls, while the young married people and the boys play a very small part except when they are specially involved in some particular ceremony.

Characteristically, a group at work on the preparation of offerings consists of a few older women and more girls than are necessary for the work, and in such a group any given girl is sometimes working, sometimes watching, sometimes playing either with a baby or with other girls and smaller boys.

The girls also have a number of conventionalized forms of play of the oranges-and-lemons and crack-the-whip types. Here again the typical play group consists of older girls and younger boys, while the boys who would be contemporary with the girls are out with their oxen or playing in separate groups.

1. Girls and small boys at a mudhole. These holes are made by the men in order to get mud for the walls which surround the houseyards. The hard work of puddling this mud is done by the men, but the children also play in it. On this occasion, they left the babies on the bank where they screamed until they were picked up. The play consisted of chasing, mock slapping, wrestling, and teetering on the edge until they lost balance and jumped into the pit. All this was done clothed, but with the sarong tucked up high (cf. the same rowdy behavior associated with water and mud in the carrying of the corpse, shown in Pl. 95).
I Renoe carrying I Malen; I Gedjar on left; I Karsa in foreground.
Bajoeng Gede. May 11, 1937. 8 M 25.

2. Girls at a wedding ceremony. In the intervals of preparing the feast, they have made "long hair" for themselves out of some of the palm-leaf strips which were used in preparing the offerings.
I Renoe on the left; I Karni wearing "long hair"; I Kemit on the right (cf. Pl. 54 for I Karni's tantrum behavior).
Bajoeng Gede. April 14, 1937. 6 V 22.

3. Girls standing on the fringe of the congregation at a ceremony. They have just brought offerings to the cere-mony and are still wearing their head cloths as carrying pads.
I Karni sitting; I Njantel with her hands to her head; I Renoe on the left; I Misi on the right.
Bajoeng Gede. Aug. 18, 1937. 13 S 39.

4. Girls in a group working on offerings. They have used some of the white clay prepared for the offerings to paint the faces of the small boys.
I Desak Made Rai painting.
Batoean. Sept. 27, 1937. 16 C 43.

5. Another part of the group shown in fig. 4. The man on the left is laying the base for a high offering, while one girl helps him by steadying the stand. The other two girls play with the baby.
Batoean. Sept. 27, 1937. 16 C 12.

6. High-caste girls playing "crack-the-whip" (goak-goak-an, literally "flock of crows"). This photograph shows part of a long line of girls running, and each girl holding the girl in front of her. The leader tries to catch the girl on the end of the chain.
Daijoe Poetoe Manis; Daijoe Poetoe Sasih; Daijoe Soekra.
Batoean. Feb. 21, 1939. 36 Q 16.

215

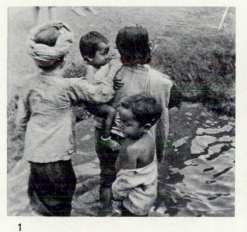

1

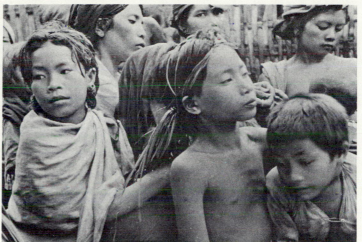

2

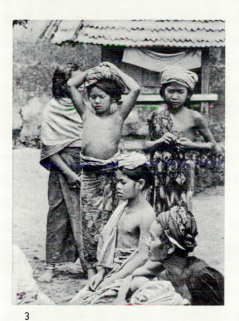

3

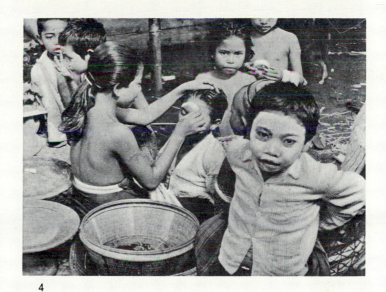

4

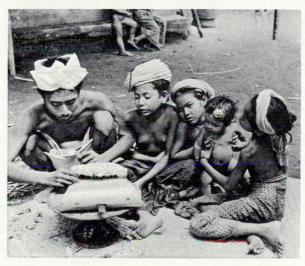

5

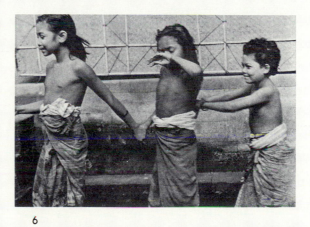

6

15

Plate 83

MALE CHILDHOOD

The independence which boys achieve at the end of babyhood is much more complete than that of girls. The boy joins a gang of other boys of his own age, whose occupations no longer center in their homes. They look after oxen, each boy taking out one animal, washing it in the stream, tethering it in the fields, and bringing it in at night. And while the ox is grazing, the boys roam the fields, scare the monkeys out of the maize, and steal bananas from the nearest garden. The boys have virtually no part in the ceremonial life of the village, beyond spectatorship at the theatrical shows. But in Bajoeng Gede, while the girls and older people are offering to the gods, there is usually a gang of little boys chasing each other around the edges of the temple courts, and before the ceremony begins, these boys are out in the middle of the temple court playing mild kicking games. There is actually very little roughness in their rough play. The only hurts that are received result from accidents, and there is almost no aggressive attempt to hurt each other. The kicking games are typical of this nonaggressive play, and the kicking movements which are directed toward the opponent, always fall short of touching him.

1. A small boy on a feast day. This boy has not yet reached independent childhood. He is dressed up in full adult costume and will accompany his mother or child nurse to the temple. Fathers also sometimes take their dressed-up sons to temple feasts. This dressing up for ceremonies will last till he is three or four years old and after that he will be left dirty and unkempt.

I Karba, aged 654 days.
Bajoeng Gede. Nov. 25, 1937. 19 G 2.

2. Small boys playing in the street. This is a pushing and pulling game in which, as in the kicking, the boys' bodies scarcely come into mutual contact.

I Nandoer facing the camera on the left; I Gedjer.
Bajoeng Gede. April 5, 1937. 8 C 17.

3. Boys playing against a tree trunk. The two bigger boys are playing a hugging game, in which the little boy has joined. This type of play is accompanied by a great deal of roaring and shouting.

I Repen with his back to the tree; I Reta, the small boy.
Bajoeng Gede. May 13, 1937. 8 U 39.

4. One boy with his arms around another boy's neck. Physical contact of this sort, in which one boy has his back to the other, is exceedingly common (cf. Pl. 38, fig. 1). Here the larger boy has his hands superposed on the smaller boy's chest, while the smaller boy's left hand holds the index finger of his own hand.

I Nandoer holding I Karta.
Bajoeng Gede. May 18, 1937. 8 Z 11.

5. A small boy just beginning to become a member of the gang. The boy on the left in this photograph is I Karba, who is shown in fig. 1. Now, fifteen months later, he is beginning to join other boys a little older than himself. He is still in the unresponsive stage which we noted on Pl. 75, and not until this is past will he become a properly participating member of the gang.

I Karba, aged 1103 days; I Riboet with arms round I Gata; I Karsa.
Bajoeng Gede. Feb. 12, 1939. 36 E 8.

6. A group of small boys romping. This scene occurred during a 210-day birthday ceremonial, when the boys were around in the houseyard, but taking no part in the ceremony. The photograph was taken just before the whole mass of boys fell to the ground in a writhing heap (cf. *rame*, Pl. 5).

Bajoeng Gede. June 4, 1937. 11 E 20.

7. A crowd of small boys at a funeral. Here again, the boys are a part of a crowd which has gathered in the houseyard before taking the corpse to the cemetery, but they have no part in the ceremonial. They spontaneously lined up in this way to watch the preparations. There was a little pushing in the line and other photographs show that the order of the boys continually changed as some were pushed out and started again at the end.

I Dira; I Toegtoeg; I Sandra; I Madera; I Doeroes.
Bajoeng Gede. Jan. 17, 1937. 4 C 26.

8. An analogous group of small boys in Batoean. This photograph shows that even among high-castes in the rich villages of the plains, the little boys have the same dirtiness and neglect. They are not quite so shabby as the boys in fig. 7, and they spend rather more of their time in such activities as drawing, painting, learning to read, etc., but the small high-caste boys of Batoean contrast as sharply with their parents as do the boys of Bajoeng Gede.

The tallest boy is casteless; the others are Brahman and Kesatrya.
Batoean. Feb. 21, 1939. 36 O 11.

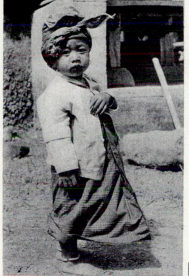

1

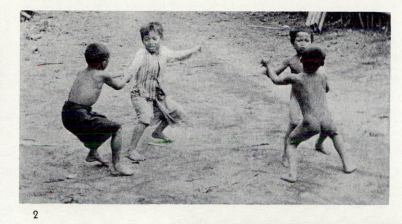

2

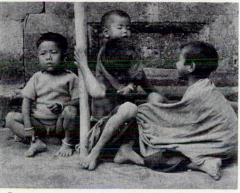

3

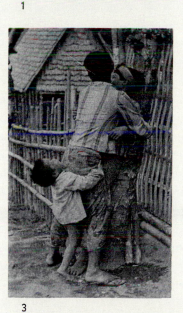

5

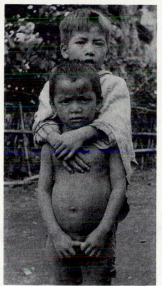

4

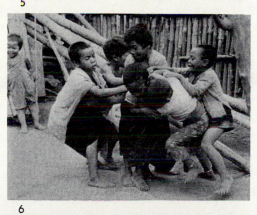

6

7

8

Harvard University, Film Study Center

The Harvard-Peabody New Guinea Expedition spent three years studying the Dani, a community of neolithic warrior farmers. A large number of people participated in that enterprise for varying periods of time, and the project produced two anthropological monographs; an ecological account by Peter Matthiessen, Under the Mountain Wall *(Viking, 1962); Robert Gardner's film* Dead Birds; *and* Gardens of War *by Robert Gardner and Karl G. Heider (Random House, 1962). This selection is taken from* Gardens of War, *a book of photographs which covers the following topics: appearances, skills, nourishment, play, ghosts and violence. The photographs and captions presented here (credited to the photographers who made them) have been selected to emphasize the way Dani society organized itself around the theme of ritual warfare.*
HSB

Introduction and Notes by Karl G. Heider
The Grand Valley Dani live in the high temperate mountains of New Guinea, which are located close to the equator. At a time when other humans were travelling to outer space, they were still in their own stone age, using polished stone adzes and bamboo knives. They were engaged in constant warfare, though they were an extraordinarily non-aggressive people. They all practice, without stress or violation, a five-year postpartum sexual abstinence. The coastal peoples of New Guinea produce some of the world's great tribal art, but the Dani do almost nothing which could be called art.

These photographs are among the results of the Harvard-Peabody Expedition which studied the Grand Valley Dani in 1961, one of whose members (Karl G. Heider) spent some two and a half years with the Dani between 1961 and 1970. The expedition was organized by Robert Gardner, whose film about the Dani, *Dead Birds,* is one of the great classics of ethnographic documentary film. Other participants—photographers, scientists and writers—were Jan Th. Broekhuijse, Eliot Elisofon, Peter Matthiessen, Samuel Putnam, and Michael Rockefeller.

The Dani live in the western half of the island, once Netherlands New Guinea, now the Indonesian province of Irian Jaya. But the Dani, like most of the other mountain peoples of New Guinea, speak a Papuan language. They are so protected by the vast swamps of the coast and the abrupt mountains of the interior that the Grand Valley of the Baliem, in which they live, was unknown to the outside world until 1938.

Like other mountain Papuans, the Grand Valley Dani live on sweet potatoes and a few other crops. They raise pigs. They wage war with spears and bows and arrows. They have little visual art, or myths or legends, yet they are great and colorful gossips, recounting ordinary events in exuberant style.

Dani warfare, because it is so well documented in these photographs and in *Dead Birds,* is one of the best known examples of tribal warfare. Two different phases of war were observed: one was a long-term ritual phase, in which two alliances would fight against each other for years. Every week or two there would be a battle or a raid, the goal of which was to kill one of the enemy and thus placate one's own most recent ghost. The enemy, however, were also Dani, and believed in the same ghosts, and killing one of them only released an enemy ghost to be placated by another death. So it went, back and forth,

Kill-the-hoop (sigogo wasin), played by boys and even girls in abandoned fields, sharpens their skill with spears. One group of children bounces a vine hoop past the other group, who try to impale it with their toy spears. (Photograph by Samuel Putnam)

The Dani have no games, no formal contests with sides, rules, and winners. Children, especially the boys, who have fewer chores than girls, do play a great deal, and most play is in one way or another preparation for adult activities. Kill-the-hoop helps prepare boys for warfare. But like all such activities, it is initiated by a group of boys who play at it as they please, and stop when they want. Adults never intervene or supervise.

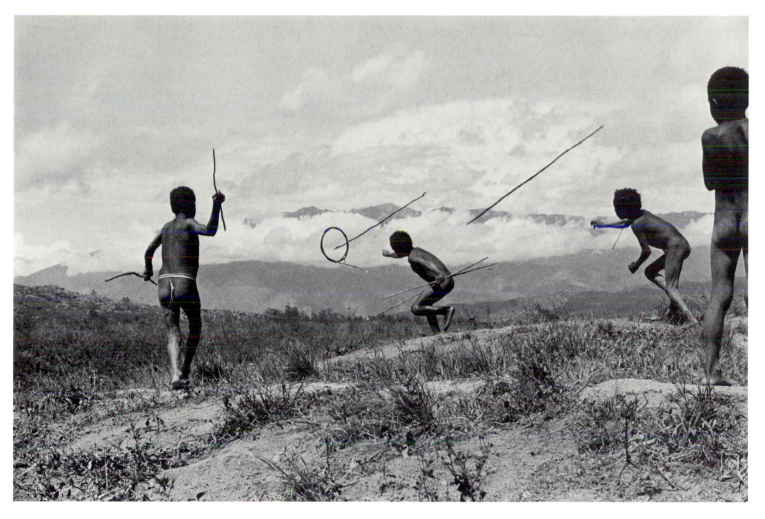

until the original causes of the war were long forgotten and a third alliance, originally at peace with one or the other antagonist, had let its relations with them reach an unforgivable point and the war between A and B suddenly turned into war of A and B against C.

This sudden shift, which usually involved treacherous massacre and was not justified by talk of ghosts, formed the second, or secular phase of war. This happened to the people pictured here just five years after the photographs were taken. A dawn attack of one half of the alliance on the other killed a couple of hundred people. The alliance boundaries were completely realigned, and, if the Indonesian government had not intervened, the ritual phase of war would have proceeded as before, but between new enemies. ◇

A battle in progress. (Photograph by Karl G. Heider)
The 300 mm lens brings the two sides closer together than they actually were. The front may stay at about this spot for an hour or more, shifting a few dozen meters back and forth as, on the right, a small and temporary advance is made.

Some men carry black or white feather wands to wave at the enemy. The man in left center, with his back to the camera, stands and shakes his long hair derisively at the men facing him. At the upper right two young leaders shout encouragement to their men.

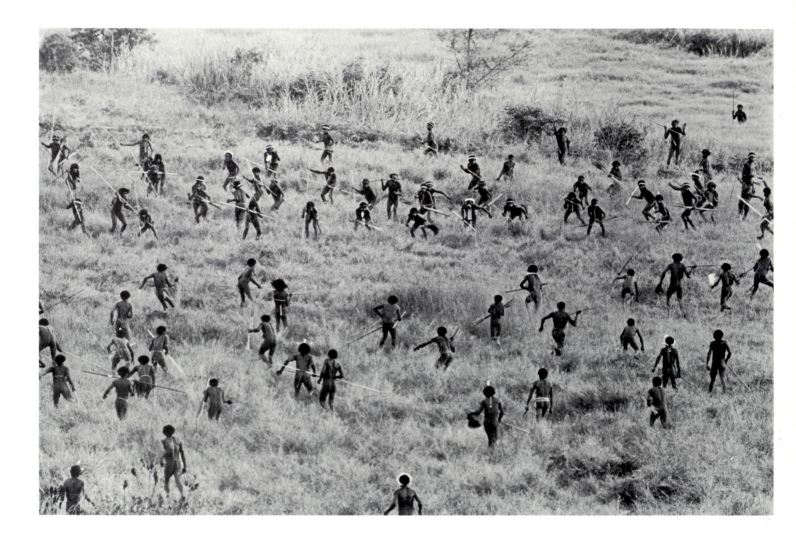

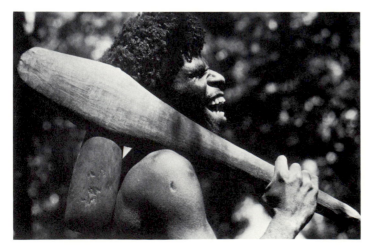

Amused by some joke, a man carries his stone ax on a shoulder scarred by an old arrow wound. (Photograph by Michael Rockefeller)
It would be easy to read into this photograph something like, "Maniacal stone age warrior, the old arrow scar on his shoulder echoing the pitted blade of his stone battle ax." Wrong. The laugh is genuine humor, common among the Dani. Surprisingly, we rarely captured it on film. The ax is not a battle ax, for the Dani used only bows and arrows and spears in battle. In fact, there were few axes around even in 1961, for most people used stone adzes for most wood-working. But axes were used for splitting logs to make fire-wood or house planks. The stone blades were traded in from the West, from a quarry which the Grand Valley Dani never visited. When the fin-

The women of the neighborhood come to a funeral to mourn and be present, but they mute their presence by draping nets over their heads. This is a time for being together, but it is also a dangerous time: the ghost of the dead person is about, and the point of the funeral is to induce the ghost—through a combination of threats, gifts, pleading and empathy—to go away and not bother the survivors. Many women smear light colored clay over their bodies and faces. This sign of mourning recalls to the Dani the little bird with the white markings which figures in the myth about the origin of death.

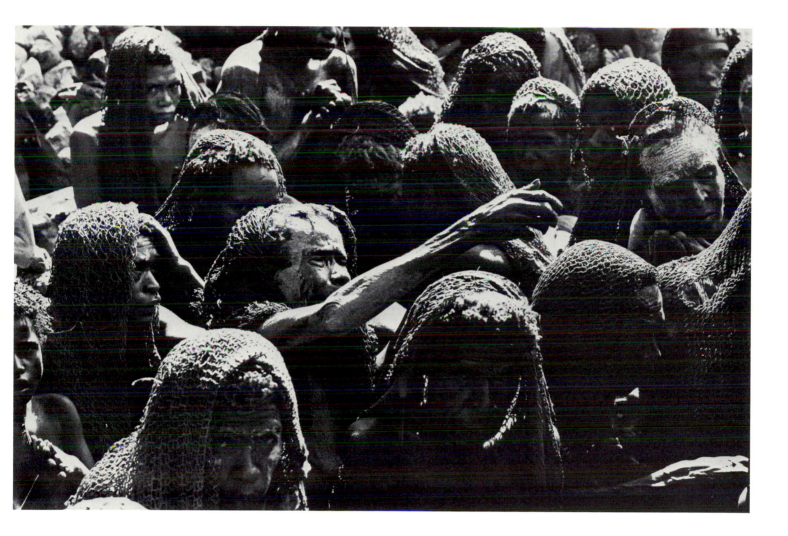

ished blades reached the Grand Valley, their current owners hafted them there, either lengthwise as axes or crosswise as adzes. In 1961 most Dani men used stone tools most of the time. By 1970, everyone still had a stone adze or two, but steel axes were in common use. The arrow wound is normal; most adult Dani men had many healed wounds on arms, legs, and bodies.

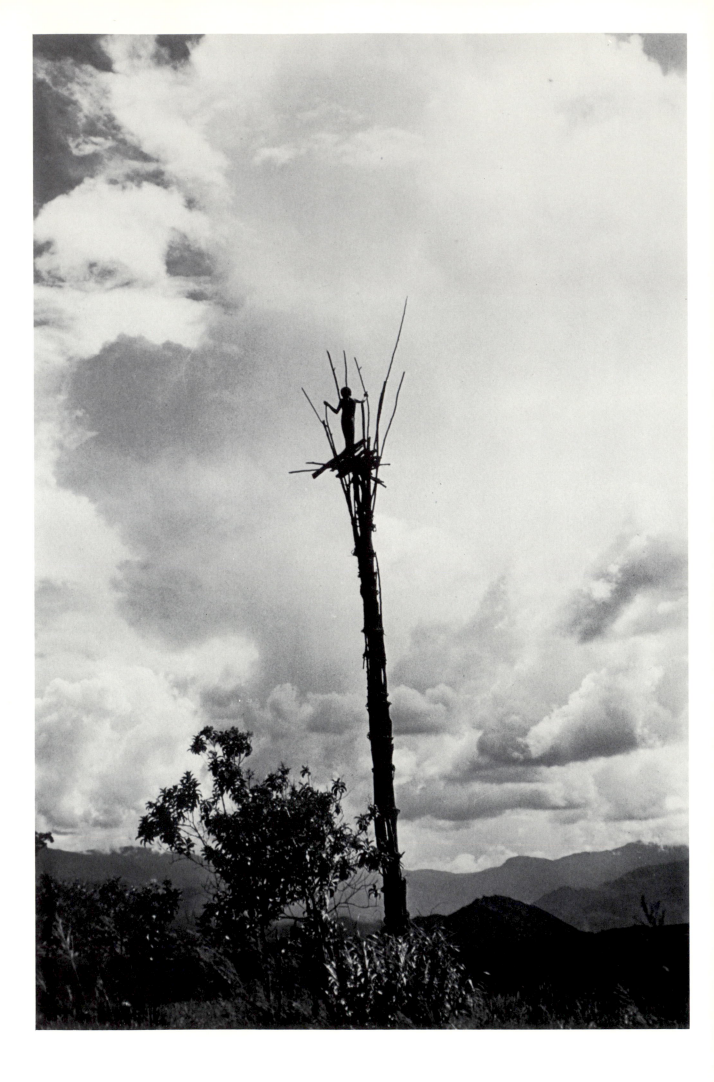

During the day, while women work in the gardens, the men take turns as sentries in the tower. (Photograph by Eliot Elisofon)

These towers are the main features of the Dani defense perimeter. Strung around outer edges of the garden zone, they face no man's land and allow the sentries to watch for raiding parties which might try to cross the unoccupied, overgrown strip which separates the gardens of the Kurelu from those of their enemies, the Widaia.

These young girls with bandaged hands have just lost one or two fingers early on the second day of the funeral ceremony. After the hand has been numbed by a blow on the elbow, the fingers are chopped off with a blow from a stone adze. Like pigs and shell goods, the fingers are gifts considered necessary to placate the ghosts. Although nearly every Dani girl loses several fingers, as a woman she does a wide range of work, from gardening to making nets, with great manual skill. (Photograph by Jan Th. Broekhuijse)

Chopping off little girls' fingers at funerals is, to us, the single most shocking Dani cultural trait. Violence of warfare—men against enemy men—we are used to. But this violence of the Dani against their own daughters in the name of their religion stretches even anthropologists' feelings about cultural relativity. It seems especially discordant with the background of gentle and harmonious interpersonal relationships. In the first years after 1961, when missionaries and government moved in force into the area and tried in many different ways to bring about changes in Dani culture, finger chopping was the first and easiest thing to go. Indeed, it was almost the only thing to go completely, for even warfare flared up sporadically despite the severe government sanctions against it. In retrospect, it looks as if finger chopping was indeed inconsistent with the main patterns of Dani culture. How it originated or why it was perpetuated is hard to say. But perhaps one can best explain its ready abandonment by its inconsistency; it was out of place in Dani culture. It was as if the Dani, at the first sign of outside encouragement, gave it up almost with relief, even as they tenaciously held on to other aspects of their culture.

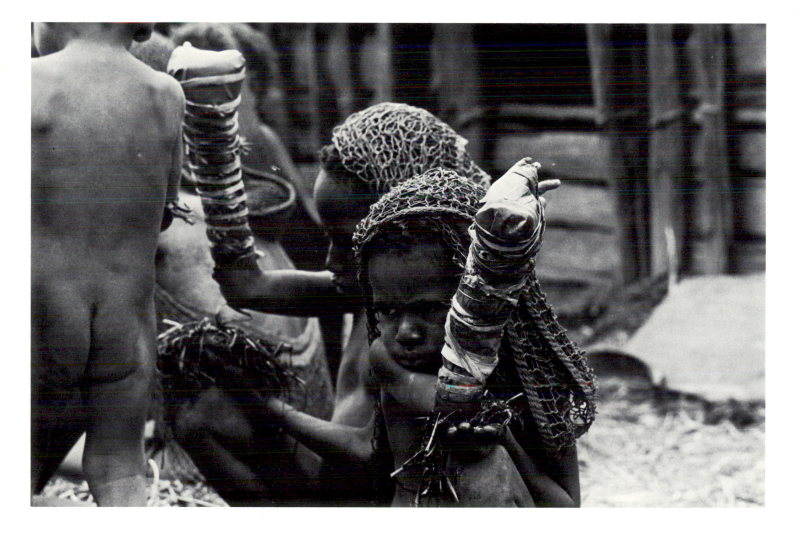

Joel Bruinooge: The Experience of Illness

Mark L. Rosenberg, MD

*Mark Rosenberg graduated
from the Harvard Medical
School and is presently on the
staff of the Harvard School of
Public Health. He describes
below the genesis of the project
from which this piece is drawn.
His work is influenced both by
his own experience as a physi-
cian and by his study of the
findings of medical sociologi-
cal research. In this piece, as in
his book,* Patients: The Experi-
ence of Illness, *he has used a
direct narrative to provide the
framework in which more gen-
eral issues of being a patient
and of the relationship between
doctors and patients can be de-
scribed and analyzed. HSB*

As a physician, I had ordered hundreds of X-rays, but I had not fully appreciated what such an order could mean for a patient. Then, one Christmas Eve, I spent three hours in the hospital with a patient, Kay Finn, who had breast cancer that had spread to her bones and caused any movement to be extremely painful. I watched her that evening as she was transferred onto a steel stretcher, left waiting in the basement hall, transferred onto the X-ray table, and finally was returned to her bed three hours later. Her experience was worlds apart from that of the physician who had written and signed the X-ray order in ten seconds. I realized my medical training had given me no idea of what it was like to be a patient.

Certainly a patient's concern with his or her illness is not limited to the duration of the encounter with the physician. But it was only by spending many hours with many patients that I came to realize the extent to which an illness could pervade and change one's life. Within the brief time allocated to most doctor-patient encounters, however, even the most articulate patients often cannot communicate their concerns very effectively. I decided to use my photographic skills to help me learn what their experience was, and to convey that experience to others. The result was a book, from which this episode is taken.

Each patient had his or her own way of dealing with illness. As a result, each chapter in the book is as much a portrait of a particular individual as it is the story of a particular disease. I was impressed by the strength these patients displayed. Though at times their strength appeared extraordinary, they were ordinary people who had been selected not for their strength, but for their willingness to talk. Perhaps this willingness to talk was a sign of that strength.

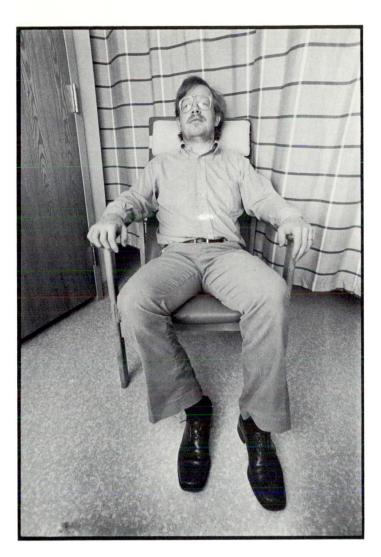

These patients were ordinary people with common diseases. Yet as common as these diseases are, the average person knows little about them. In our ignorance, we may think these diseases are more disabling and more disfiguring than they really are. In our culture, there are very few ways to correct such misimpressions. Pictures of sick people are conspicuous by their absence, and the segregation of sick people into hospitals and nursing homes ensures that most of us will never see "the real thing". An unfortunate consequence of always keeping illness under wraps is that we might come to think that sick people are too horrifying to look at. And if we can't look at them, we certainly can't talk to them. In the end, we may leave patients unable to talk about their illnesses with family or friends just when they are most in need of support.

I was particularly concerned about whether my photographing these patients made their experience with illness more difficult. Certainly, standing before a camera can make one acutely self-conscious. But being conscious of one's self and one's appearance need not be disturbing. How the subject feels depends, in part, on how the observer and subject interact, and this shows up in the photograph. These photographs reflect relationships that evolved over time. Sometimes these relationships became quite close, especially after we had spent time together during some particularly difficult or painful experiences. Yet despite this closeness, there were times when patients did not want to talk to me or be photographed. Three months after we had met, Kay Finn decided that she did not want to continue meeting with me. In fact, from that point on, she also chose not to meet with any friends or family members except her sister. This withdrawal was probably part of her preparation for death, which came four weeks later. On the other hand, when I asked Jeanne MacLaughlin how she felt about having been photographed during a difficult period, she replied: "At the moment, I had been feeling very rejected, and with your support and your interest, you lessened that feeling of rejection to some degree . . . because you were a man and you were not afraid to look at me. I could not understand why my husband was. It just helped. I can't explain why or how, but it did help." She seemed to be saying something which was confirmed by other patients as well: we can all give something valuable to someone who is ill by being willing to see and willing to hear. Then, perhaps, we can begin to understand more fully what the experience of illness can mean. ◇

[Excerpted from the introduction to *Patients: The Experience of Illness* published by The Saunders Press, Philadelphia.]

Joel Bruinooge, 26 years old, worked as a writer and editor in the public relations department of a large insurance company and had been married to Meg Crissara, a pianist, for almost three years when he suffered a stroke on January 13, 1977. The stroke resulted from a blockage in one of the vertebral arteries which supplied blood to parts of his brain, and it caused him to have difficulty with speech and balance. It is very unusual for a stroke to affect men as young as Joel and though his physicians performed a multitude of diagnostic tests, they could find no physiological explanation for why he had the stroke.

He made a gradual recovery and returned to work six weeks after his stroke. On April 22, however, he suffered a heart attack caused by a blockage in one of the arteries that supplied blood to his heart. He was hospitalized for another three weeks and returned to work shortly thereafter. In October 1979 he was still working full time, having been promoted since his initial illness.

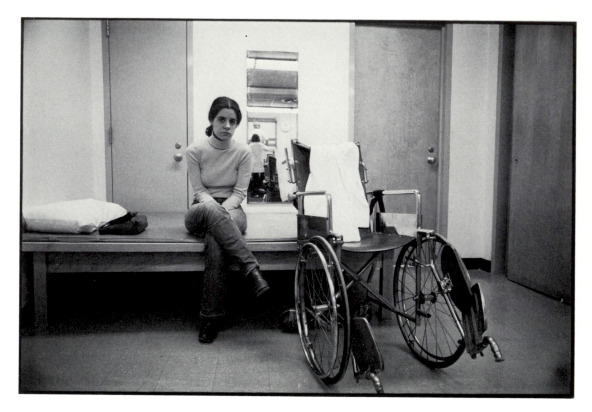

Meg Crissara:
(Joel's wife)
In the beginning I was really afraid he was going to die. One of the doctors said it's either a migraine headache, an aneurysm or a brain tumor. He said that so matter-of-factly, but it sounded like things were not going to be good at all. I was frightened and I couldn't sleep. After they did the angiogram, Dr. Caplan took me into the solarium and sat me down. He told me it was a vascular occlusion—and I had to ask him what that meant. So he told me Joel had had a stroke. I couldn't handle it at all. I was petrified and I just cried a lot. He was really kind, and he stayed with me for a long time, maybe 15 minutes, until I was a little better.
January 25, 1977

Meg Crissara:
I remember the first time the physical therapist came in to try to help him walk. She picked him up but he wasn't doing very well and he couldn't take a step. I started to cry, and left the room so he wouldn't see.
May 7, 1979

Joel Bruinooge:
This is not like anything else. I have never been in a place that I couldn't get out of. What scares me the most is the fear of being a cripple.
January 26, 1977

Joel Bruinooge:
Sometimes I start laughing like an idiot and can't stop. The part of my brain that was affected controlled my suppression reactions, so now things I would normally suppress automatically come to the surface. I feel like I don't have any control.

Meg Crissara:
I've loved you the whole time, but I like you even better now that you're so open about the way you feel. Sometimes, though, when I see a lot of laughing or crying I wonder whether you're actually feeling all that much . . . or whether your body's taking over.
February 1, 1977

26

Meg Crissara:
(after Joel's return home)
One of the basic areas where we communicated without having to talk was sex. It was always very nice and I never had to be the one that said, "Well, why don't we?" Now, we don't share that area of communication as often or as comfortably as before because it's a little bit awkward for him. He gets tired much faster. I don't walk around thinking about that but it's an outlet we just don't have now.

Sometimes Joel calls himself a cripple and I get absolutely undone. We don't discuss it except to say, "Of course, everything's going to be fine," but underneath there is that big question.

Joel had always been very supportive of me and, in a sense, our relationship centered around his doing as much as he could so I could practice the piano six hours a day and perform. When Joel was hospitalized, the rest of my life basically stopped.

All the stuff that we shared before is now my responsibility. Being emotionally strong and not falling apart is also my responsibility. If I'm home and I cry Joel asks me not to because it gets him upset. So I either have to go out to the sidewalk and cry, wait until he is out, or not cry at all.

My friends and our parents are much more concerned about Joel than about me and that's understandable. If somebody calls and asks, "How are you doing," they really want to know how Joel is doing. Nobody says, "Well Meg, how are you?"

Joel used to ask, "What kind of a day did you have, what happened to you today?" He still does ask, but now he does it for form's sake—he's so busy getting better and the daily pressures on him are so incredible, that he can't really deal with my day.

I never had to give like this before. In the beginning I felt really great, my insides really wanted to give and when I found an outlet for it it really felt good. But now this has been going on long enough. It gets to be a strain.
April 7, 1977

Joel Bruinooge:
I could tell you that it's very frustrating to try to learn how to tie your shoes for the first time, or it's very frustrating to have your attention span be only five minutes, but I don't think you would appreciate that unless you had gone through it, or you had seen someone you know well have to struggle with it.
January 1, 1979

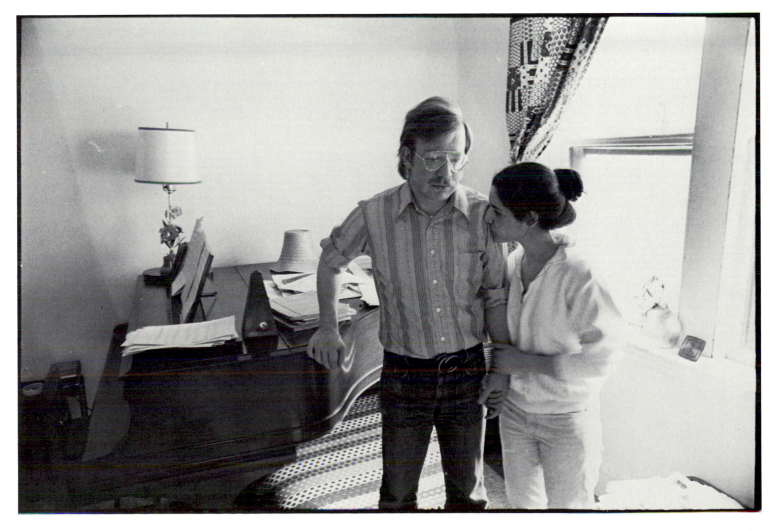

Meg Crissara:
Even when people who are close to us call up wanting to see how we are, they will never refer to what actually happened to Joel nor ask him how he really is. They always say, "Gee, you look fine, ya know. Everything's gonna be all right." They're embarrassed, but they keep it all underneath: they know something's funny, Joel knows something's funny, but nobody will say anything about it.

Joel Bruinooge:
The neurological damage makes me look like I'm drunk, and every time I have to move I can see people say, "Hey, what's with him?" It also means an incredible amount of work to stand up on the subway all the way to downtown. I tried carrying a cane so people would give me a seat. I ended up standing, holding the cane.

Meg Crissara:
Since Joel talks a little slower and not quite as loudly as he used to everybody talks more slowly and louder to him. His slow speech makes it sound like his mind isn't working either. People can't separate what comes out of his mouth from what's going on in his head. It's like seeing a blind person and assuming he is deaf as well as blind.

Joel Bruinooge:
It's like I'm some kind of dummy.
March 6, 1977

Meg Crissara:
At the hospital Joel was getting a lot of encouragement and feedback every day about how well he was doing. It means a lot more to be told by a therapist or a doctor that you're getting better than if your wife just says, "Gee, you look better today." So today we went back to the hospital for therapy, and everyone who means something to Joel medically told him he was much better.
February 13, 1977

Joel Bruinooge:

After the heart attack, the cardiologist told Meg I could probably never be a father because the strain of staying up all night or playing with kids would be too much. He wouldn't talk to me about it because he felt it would be unwise to subject a patient to the stress that kind of discussion would generate.

But the real stress for me was living in dread that something else was going to happen. I don't know any better now whether I'll have another heart attack or stroke, but I can't go through my life waiting for it to happen.

Meg said she wanted to separate the day I came home from the hospital after the heart attack. I think even before I had had the stroke there were tensions in the marriage. I was more pragmatic than she was—because I had to be. I felt I had assumed more than my share of housekeeping and domestic responsibilities. I took care of everything and she concentrated her total awareness on playing the piano. She was not interested in my job—she wanted me to quit and write a novel—and I wanted her to pursue a career with financial rewards.

My illness brought these differences to a head. It threw the total load of daily chores—from buying food to making out the income tax—on her. It forced a complete change in her life's priorities, and she was afraid it would limit what she was going to do with her piano. It was life-threatening in a sense: it threatened our hopes of what our lives were going to be.

Meg left about two weeks after I came home from the hospital. She felt that the stroke and the heart attack were harder on her than on me. At first I was pretty angry. I felt betrayed. Then the anger was replaced by a sense of loneliness.

September 11, 1977

Joel Bruinooge:
On April 21st, about ten o'clock, I just had a little bit of chest pain. I had had pain like that before but the doctor had thought it was caused just by anxiety. I thought I'd go to sleep and it would go away. It was still there in the morning when I woke up, so I got dressed and took the subway to work. It hurt pretty bad and I started to perspire on the sub-way. It started to hurt worse at work so I went to the clinic and they sent me here. When I got here they gave me morphine and said I was having a heart attack.

I remember lying in the hospital bed after the heart attack thinking that my problems now had become very finite: whether I could move my left hand or whether I could pick up that nickel. It was a relief. I had the very strong feeling that the lifestyle I had been living was wrong for me—for example instead of doing what I wanted to do I would end up carting Meg around so she could do what she wanted to do: play a concert or practice. The stroke and the heart attack gave me a chance to say I quit, they were a way out.
May 7, 1979

Joel Bruinooge:
It's funny to be a guinea pig for students. In the morning, all those people walk in and say, "Come on, do this, don't do that." It's like they're playing with me. "What's he gonna do today—jump hoops?"
January 26, 1977

Meg Crissara:

After Joel began to recover, his feeling was, ''Oh, I can live, I can, oh, wow, how great! I can go back to work! Look at this, I can get dressed!'' My feeling was, please, I need to rest.

We were both pushed to the brink and made to question what it means to be living. But after stepping away from that, the quality of day-to-day life just changes: it's just much, much fuller. Still if someone had suggested to me while I was going through it, that it was going to be a positive experience, I probably would have told them to shut the hell up. I didn't want to hear it.
May 9, 1979

Joel Bruinooge:

I'm kind of stuck where I am. I will probably spend the rest of my working life with the same employer because, obviously, another company is not going to want to assume my medical risk—it's just easier to get somebody who doesn't have these problems. Free-lance writing is out now, because I need the medical benefits I get with my job and I can't buy them on the open market.

Meg Crissara:

When Joel went back to work a week ago, they gave him a physical exam. They asked him to count backwards from one hundred by threes and he started to do it faster than the nurse could figure out if he was correct or not. I think it was like being insulted to be asked these things. Joel also had to get completely undressed then dressed again within less than an hour and a half—a big, huge effort. That physical exam was so painful that Joel cried the whole afternoon and evening—it took a full day before he could even say what was bothering him.

Joel Bruinooge:

It made me feel like a turkey because they wanted to see if I could think or not.
September 11, 1977

Joel Bruinooge:

In some ways I consider myself very lucky for having had the experience. It's allowed me a chance to sit back and look at my life. I'm happier with the way I live now than I was before I had the stroke.

After I had the stroke I decided that I didn't want to expend energy on playing games with people, telling them what they want to hear. It's not just being more honest with myself—it's being more honest with other people.

Work is less stressful because I can look at situations that would have produced stress for me before and say, ''That's not a problem—I have had problems.''
May 7, 1979

John Collier Jr.

John Collier Jr. is professor of Anthropology and Education at San Francisco State University and also teaches photography at the San Francisco Art Institute. He is the author of a classic text, Visual Anthropology, and has trained many anthropologists in the use of photography and many photographers in the use of anthropology. He was a member of the Farm Security Administration Photographic Unit and has done photographic field research in Peru, Nova Scotia and elsewhere. His exploration of the problems of native Americans relocating in American cities embodies classic themes of both anthropological studies of personality and culture and of documentary photography. HSB

The essential policy of the Bureau of Indian Affairs was to eliminate the American Indian, a policy referred to as "termination". At the turn of the century that was not an unrealistic aim, for Indian populations were vanishing, unable to adjust to custodial reservation life. Although a few white Americans fought this policy of extermination, the vanishing of the red man seemed natural and inevitable. Termination guided all federal policies consistently until the Roosevelt years of the 1930s. In the administration's reassessment, not only were native Americans found to be generally impoverished in health, welfare and education, but they also proved to be one of the United States' rapidly expanding minorities. The Indian had not vanished and, instead, had become a scandal due to neglect by the federal government.

Under Roosevelt, the policy of the Bureau of Indian Affairs changed radically, from the liquidation of tribes to the reconstruction of their economies and welfare and the democratic right of self-determination. When a Republican administration returned to power, the winds of change reversed the Bureau's policy again, back to its original goals of terminal custodianship of the American Indian.

The first phase of this changed policy came in the Eisenhower administration's efforts to terminate tribal ownership of lands by direct payment to individual Indians. That brought about a hornet's nest of Red Power. This initial effort was abandoned after eliminating two Indian reservations, the Klamath and the Menominee. Significantly, these lands contained the largest stands of virgin timber in the United States.

Eskimo family living in
Alameda, California.
Loneliness is a threat to the
spirit of relocated native
Americans.

The second effort to liquidate Indian landholdings and
culture took the form of a massive program to relocate
Indian peoples to western and midwestern cities: Chicago,
Denver, Los Angeles and San Francisco. The Bureau sup-
plied free one-way tickets to Indians seeking jobs in these
urban centers. The BIA organized token job training and,
once it found a relocatee a job, all responsibility of the
federal government ended.

In 1965, San Francisco State University (with a grant from
the National Institutes of Mental Health) studied the accul-
turation and adjustment of relocated Indians. One level of
observation was photographic, a documentary survey of 24
Indian homes. I studied the environment of Indian homes
with a view to the degree of success on relocation—a visual
ethnography of urban acculturation. We found a direct rela-
tionship between adjustment to relocation and the "look" of
an Indian home. A family's ability to achieve cultural order
in the home reflected its ability to cope with urban life.

The federal government defined successful relocation as
terminating an Indian in the urban industrial wilderness. For
native Americans, successful relocation was a more complex
matter. For many, it meant a free trip and some valuable life
education before settling down again in their Indian home-
lands. For many others, the relocation that was meant to
produce the assimilation of Indian identities instead galva-
nized Indian personalities and created aggressive Red Power
activists. The federal planning for relocation had a basic
flaw, for the very experience that was designed to cause the
disappearance of Indian identity instead exploded in the
opposite direction.

Unpredictably, urban survival required strengthening the
"Indianness" of personalities. Without that, people failed,
in neurosis or alcoholism. So relocation, a scheme designed
to lose red Americans in the nation's cities, instead caused
a revival of modern American Indian vitality. Indian culture
did not effectively follow red emigrants into the cities. But,
Indian music, created for survival in the city, circulated
back to the reservation.

The significant result of the policy of relocation, one that
still remains, is a resurgence of American Indian
culture—not only richly costumed dances and songs, but an
aggressive and sophisticated Red Power political energy,
the last thing the Bureau of Indian Affairs wanted. ◇

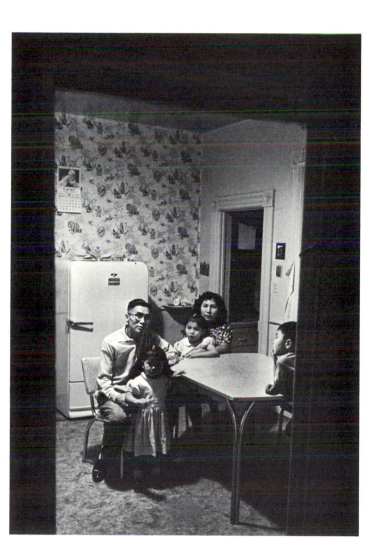

Pomo family. The quality of
education is a major variable in
adjustment to relocation. City
life is frighteningly complex and
can exploit the migrant Indian.

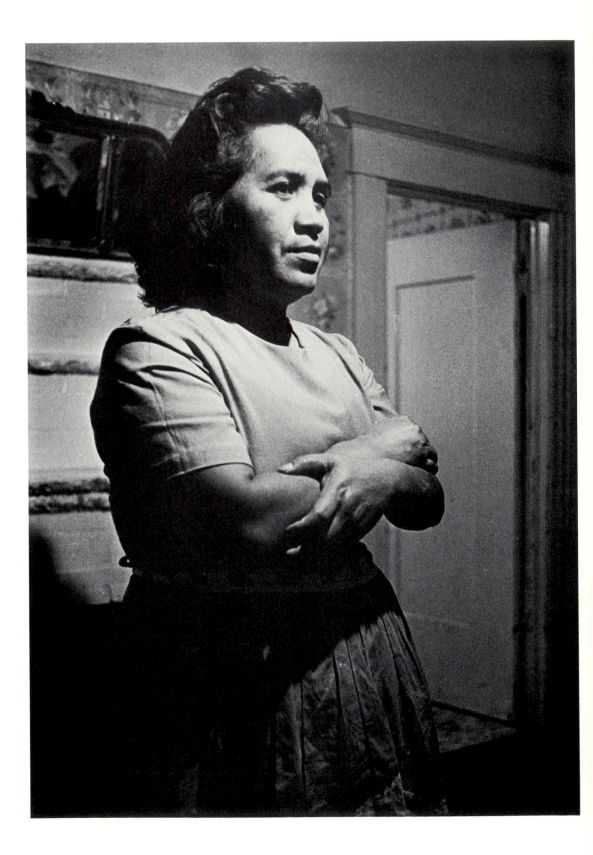

Pomo family living in Oakland,
California.

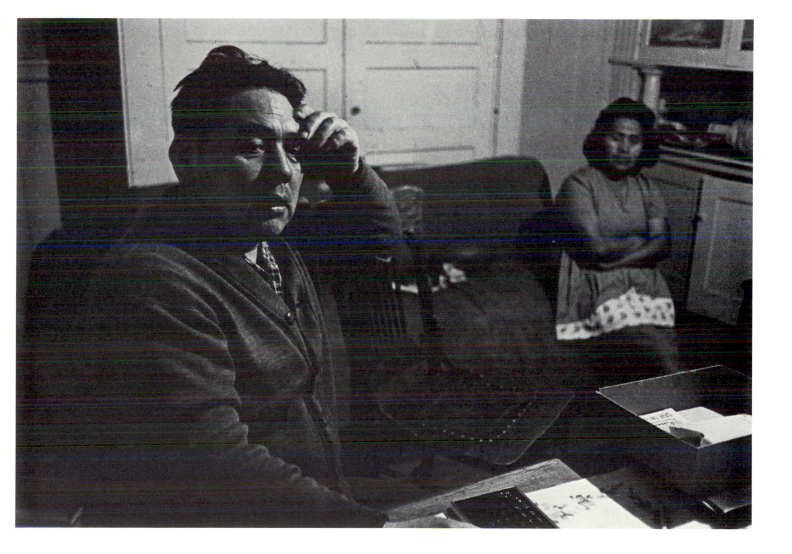

Sioux family living in Alameda.
How does a relocatee express
himself as an Indian? Drinking
is often a first opportunity: it
allows mingling with other
Indians. But later there usually
comes a reassessment of Indian
self, to find new energy to
succeed in relocation.

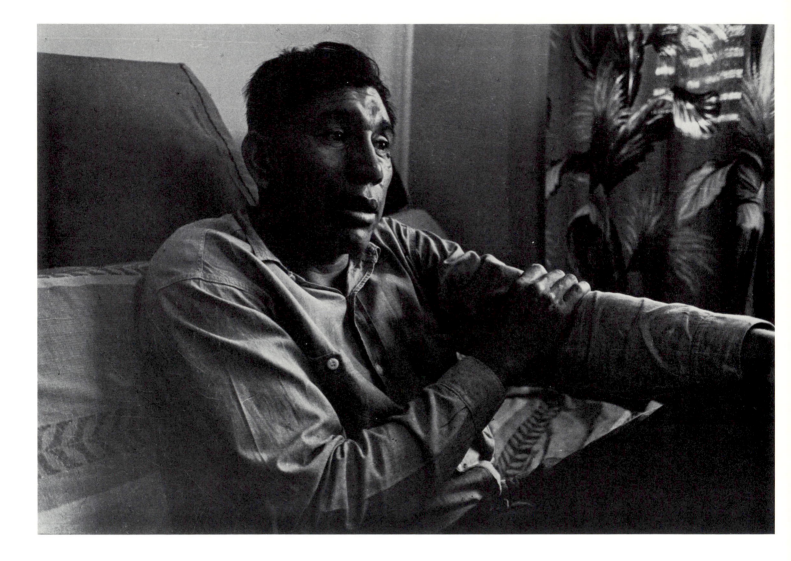

Indians on relocation cling to symbols of their Indian identity, as anchors in the turbulence of urban survival. An Indian flute shouldn't be photographed.

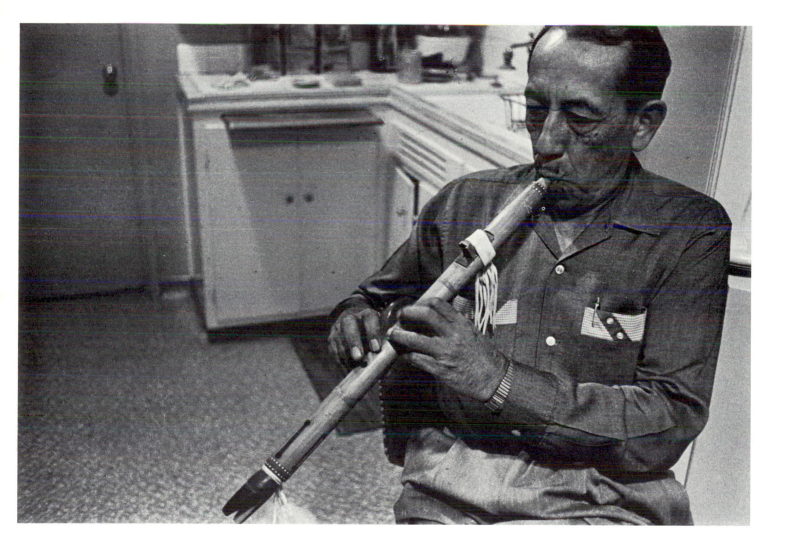

Sioux home in Alameda,
California. Nature's presence
often dominates the decor of
Indian urban homes.

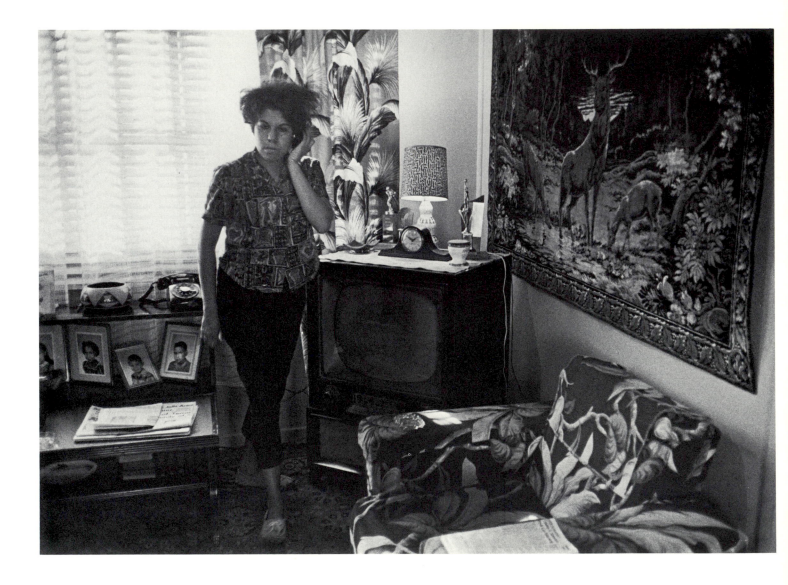

Navajo married to a Walipi
living in Palo Alto. Indians
must find renewal in the
unfamiliar surroundings of
urban living.

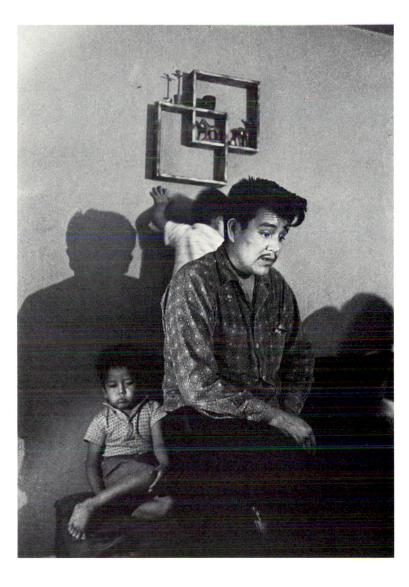

Bruce Jackson

Bruce Jackson is a folklorist,
novelist, photographer, film-
maker and professor of English
at the State University of New
York in Buffalo. He began his
research in prisons when he
was a member of the Society of
Fellows at Harvard University.
That research has now pro-
duced several books, including
Killing Time (Cornell University
Press, 1977), from which this
piece is drawn, and the film,
made in cooperation with
Diane Christian, Death Row.
The book quotes a conversa-
tion Jackson had with inmates
which explains his procedure:

Time and again, Cummins
prisoners asked me whose story
I was going to tell, "theirs or
ours". "Mine," I said, "That's
the only one I know."

Most thought that fair
enough, but a few said, "What
about the stuff you don't see?"
"I can only photograph what I
see," I said.
"What are you going to say,
then?"
"I'll print the pictures and
some quotations from you and
them and let the pictures and
quotations say what they have
to say."
"But which pictures will you
print?"
"The ones that say what I
saw." HSB

Killing Time: Life in the Arkansas Penitentiary

These photographs are from my book, Killing Time, a
collection of interviews, scraps of official reports and
newsclippings, and 130 photographs I made in Cummins
Prison Farm. Cummins is located a few miles south of
Grady, Arkansas; it is the Arkansas prison for adult male
felons. Cummins is the real-life prison caricatured in the
movie Brubaker.

All prisons are terrible places, but Cummins got so good
at being terrible that it became the first American prison to
be found unconstitutional by a Federal court. When I first
visited Cummins in summer 1971, the court order was al-
ready in effect and improvements had begun; when the last
of these photographs was taken four or five years later,
Cummins was a much better prison than it had been. By
then, it was no worse than many other American prisons
and it was probably better than several. On a relative scale,
that means a lot; it surely meant a lot to the inmates, who
no longer had to worry about being beaten or starved to
death. On any kind of absolute scale, the differences col-
lapse; the great leap forward from horrible to merely awful
doesn't seem so great.

It is impossible to do serious social documentation with a
camera without some informing theory: there are too many
chances for selection, options for inclusion or exclusion,
too many choices made.

My theory of prisons would probably begin with my be-
lief that prison doesn't do anyone much good. There are
some people who have to be locked up; they are just so
nasty we can't afford to have them running loose. That's too
bad, but that's the way it is. I think it is reasonable to keep
such people off the streets until they learn some other way
to get by. The problem is, they don't seem to constitute a
very large portion of the people behind bars. I keep thinking
that a society as rich and sophisticated as this should have
some other way to deal with people whose systems are
poisoned by heroin or alcohol, or with people who are too
dumb or uncharming to make it well in the competitive
world of stores and offices and schools.

Most people in prison are damaged by the experience in
ways the Chi-square analyses of social scientists can't begin
to calculate. For one thing, the qualities of behavior needed
to make it well in prison are exactly the opposite of those
needed to make it well in the free world—initiative, curios-
ity, independence—and that is why rehabilitative programs
are always irrelevant or peripheral, why they fail.

Some people in prison learn to read and write and they
are therefore better equipped to deal with our world than
they were before, but since it costs about $12,000 a year to

40

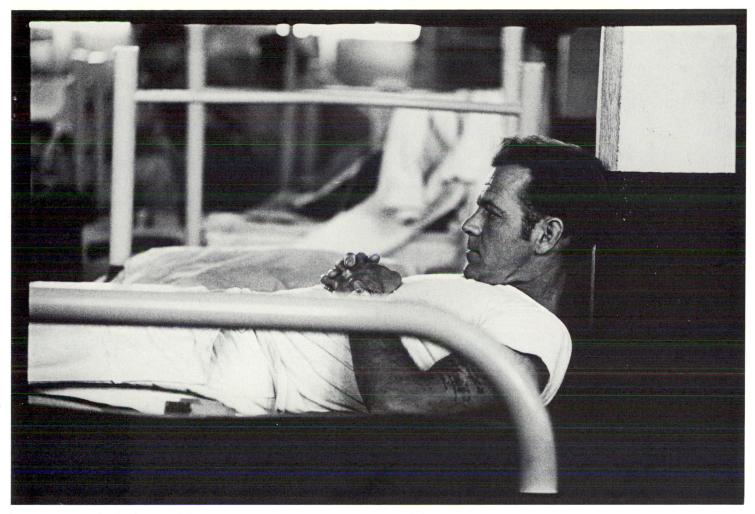

keep someone locked up and the total cost of tuition and room and board at places like Harvard and Yale and Penn now runs about $7,000 a year, that seems a stupid economy, if mere retooling is the goal. [These are 1977 figures.]

I think the primary function of prison is to hurt people, and prison succeeds at that quite well. I doubt if most people who run prisons think hurting people is their job; most of the administrators I know try to make prisons as humane and helpful as they can. The reason they fail is that there is no way to make a cage humane and helpful. So they keep on trying and they keep on failing and they always look a little puzzled when they find that not only do the inmates hate them, but so do the free-world people whose social garbage they are charged with secreting. I won't say anything about the guards and wardens around the country who are deliberately mean and cruel: they've been written about by others who know them better than I, and I suspect they're in a minority anyway. I worry more about the decent people in ''corrections'' who manage to do evil things because of fear: fear of the convicts, fear of their fellow workers, fear of the press, fear of the legislature, fear of their own sure knowledge of how easily they might be wearing that other uniform.

The problem is, there is no way to do the job decently, because the idea isn't decent. The best one can hope for is a parody of civility, a parody of society.

And that is another part of the theory behind these images: as I said before, people *live* in prison. They don't live well, but live they do. They make spaces for themselves, decorate what they can, define as private the tiny areas they can manage to control; they negotiate hustles and seductions and friendships. For most of the outside world, the inmates are locked away for a period of years and are totally invisible. Except for Attica in 1971 – when for a little while angry inmates spoke directly into the living-room television sets before they were murdered – there have been no live broadcasts from these places. The information on television, in the press, and even in books like this is packaged and arranged neatly by people comfortably outside and far away from those high walls and barbed-wire fences.

For most inmates, one day follows another, and each day is filled with the things days everywhere are filled with: work, sleep, filling the body up and emptying it out, keeping alive and staying sane, making as few compromises as possible, and hoping tomorrow's compromises will go down easier than today's.

My theory would end with this: Some of them look like you. And me. ◇

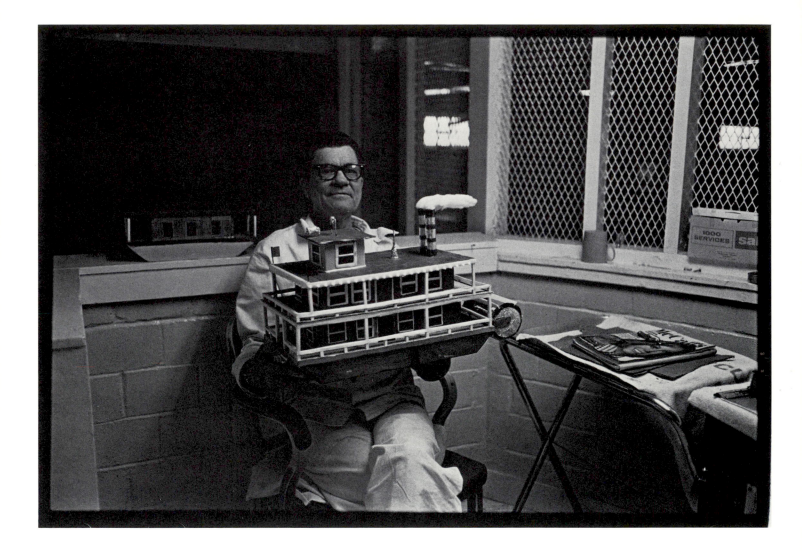

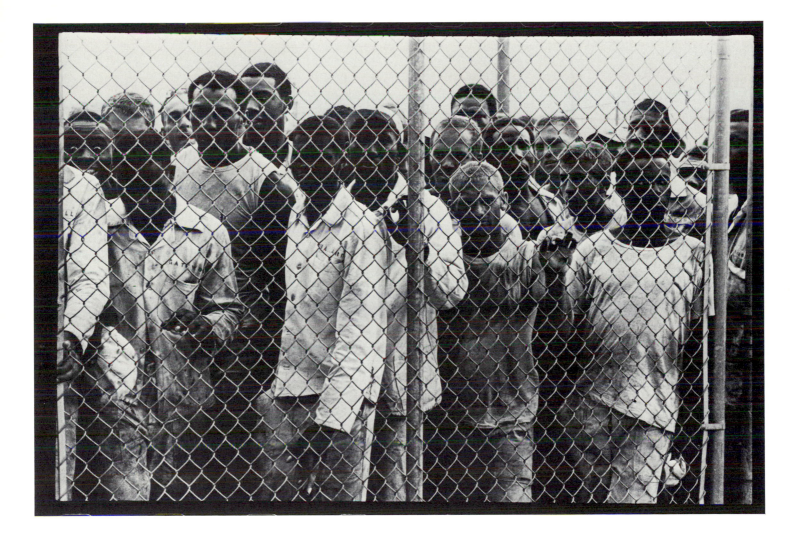

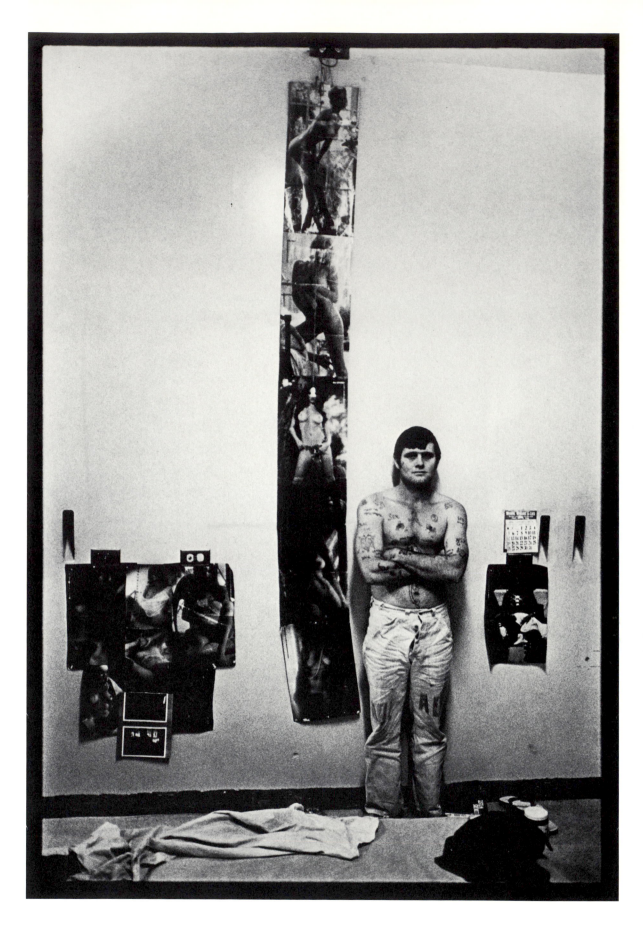

44

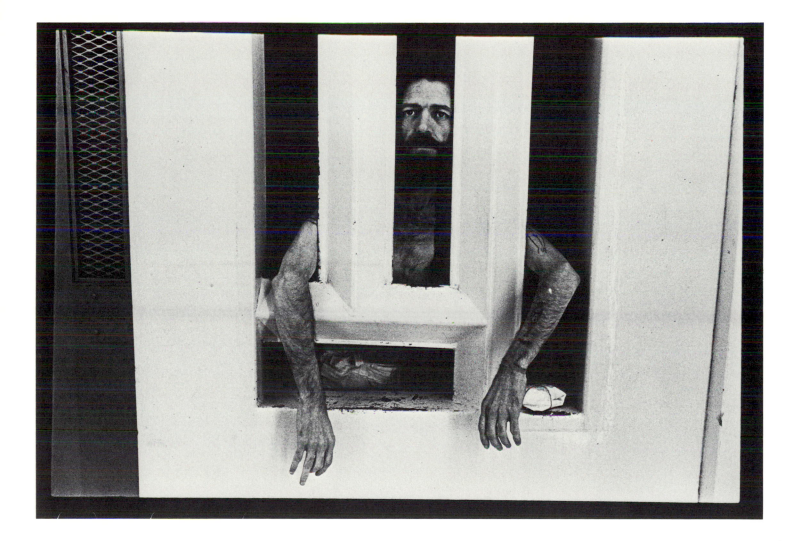

Two Views of Venice, California

Bill Aron

Bill Aron received a PhD in sociology from the University of Chicago and spent several years doing sociological research. In the course of work among the declining and aging Jewish community of the Lower East Side of New York, he began to photograph the people he was studying. As his interest shifted and he began to exhibit his photographs, he gradually switched his professional allegiance so that he now works as a photographer, doing a little teaching in sociology on the side. In this piece, Aron has looked into two very different cultures—a community of elderly Jews and that of the roller-skating world—which inhabit different parts of Venice, California. He is not dealing with two communities in actual contact with each other, but rather with two styles and stages of life, using each to highlight features of the other. He has done that in a way that is unusual in "documentary" work, by directly superimposing images of people and events that in fact have never had anything to do with one another. HSB

Between 1979 and 1981, I worked on two separate photographic projects, located at different points along a two mile cement boardwalk in Venice, California. The boardwalk in Venice is unlike any other stretch of ocean front in southern California, with restaurants, fast food establishments, grocery stores, an open air gym ("muscle beach"), skate rentals, one book store and residential buildings, all sandwiched together. Within this stretch of beach front, two worlds coexist: one old and the other young; one at the northern end and the other at the southern end of the boardwalk; one composed of survivors, the other of people still being tested.

Venice I: Approximately 4,000 elderly Jews live in Venice. Most immigrated to this country from Eastern Europe, pausing briefly on the East Coast, and then continuing across America with California as their final destination. Anthropologist Barbara Meyerhoff, in *Number Our Days* (E. P. Dutton, 1979), has characterized these people as survivors of a special kind. Despite their age, they are a politically organized and socially active population. They are passionate, full of pride and independent, helping those they consider needier than themselves. Many volunteer their time and services to other elderly groups throughout the city. They exercise regularly, often walking as much as five or six miles daily. For them, survival is a full time occupation and they work hard at it: they do whatever is necessary to remain as healthy as possible, whether that be a twice-daily swim in the ocean to combat arthritis, or a dangerous operation to implant an experimental pacemaker.

In the summer of 1979, the Hebrew Union College Skirball Museum commissioned me to spend four months photographing the elderly Jews of Venice. During the course of the project, I found myself profoundly affected by their vitality. The forcefulness of their personalities was so engaging that I wanted to fill the viewfinder with them—with their hands, their faces and their histories. I felt compelled, in most cases, to focus in on the life I found in this population whose ages ranged from 65 to 95. Nothing else seemed appropriate or important. I tried to make the photographs tell complete stories, as if the whole of their realities was within my viewfinder and looking at me.

These quotes from some of those I photographed reveal their character:

Sam: "As a youth, I lived in the face of the Russian Revolution. That spirit has moved me my entire life and colors everything I see."

Sadie: "I am a believer in the ecumenical outlook. We should all be friends. It's very important for us not to judge."

Minnie: "I am entirely up on what's happening to seniors. The cuts the President is making are being borne by those that can least afford it."

Bertha: "I have a lot of good friends, thank God, and people who know me and know who I am. But some of the people don't realize [who I am]."

Pauline: "He said, 'Would you fight for your country if you become a citizen?' I said, 'I believe in peace.' 'Oh, no,' he says, 'that's not what a citizen would say.'"

Venice II: The other Venice is the roller-skating capital of the world, a circus, a wonderland of entertainment. Its people are preoccupied with the body and with showing it off—skin and sex jump out at you from every direction.

From all over Los Angeles, a radius of about 50 miles, people come to Venice to be seen, to perform and to be discovered. There is also "the crowd", which comes to watch and appreciate. Jugglers, fortunetellers, sword swallowers, comics, snake tamers, fire-eaters, weight lifters, musicians, skaters, dancers, mimes and beautiful bodies suggestively dressed come to Venice to "do their thing". And the crowd loves it.

Roller-skating dancers, alone and in groups, slide in and out of each other's arms and legs to the deafening pulse of disco music. Slalom skaters whirl down the course in all manner of contortions. Stunt skaters sail over a lengthening row of garbage barrels to touch down, not always firmly. The bulging steroid-toned bodies of muscle beach lift enormous weights, do uncountable numbers of calisthenics and parade ostentatiously before cheering spectators. The crowd enjoys it all; when it no longer does, the next performer takes over.

What Hollywood and Vine was to Marilyn Monroe, Venice is to today's aspiring stars. Beautiful bodies, professional dancers, stunt men and women do whatever they can, hoping to be seen by "somebody important". In 1980, for example, several films were made about skating and several more used skaters from Venice as extras. There is always at least one television or movie camera around, and "stars" make regular appearances in the area. "Discoveries" sometimes do happen:

Tony: I used to be an electrician. I just "discoed" on weekends for fun. Venice is the best place, so I came here. One week, this guy says to me, "How would you like to do that for money?"

Richard: I'm a professional stunt man. I come to Venice to show off because this is where it's at.

Julia: I was a professional dancer and not getting work. Skating became popular, so I put on skates and kept dancing. I'm doing the same thing I've always done, except with skates. I just got back from a tour in Europe with a troupe of skating disco dancers. I come to Venice to work out in front of an audience.

Whatever the fantasy, Venice is the place to bring it.

Nothing in my background prepared me for Venice. I was fascinated, and immediately made it a photographic project. For two years, I ran to the beach whenever possible, in any weather, camera bag on my shoulder, to shoot another roll of film. I experimented a great deal, looking for a style that would adequately convey the complexity of my emotional response to the beach culture. The style I eventually evolved attempts to give the viewer a "cross section" of the scene. Because the stories of Venice could be viewed from an infinite number of reference points, it seemed appropriate to emphasize the fragmentary nature of each frame. My previous ideas of a good photograph changed dramatically: I no longer had to show the head on every body; I could cut it off for emphasis. I did not need a congruent relationship between the subject and the background. People and objects did not have to be what they appeared to be.

In this piece, I wanted to focus on the relationship between these two Venice "communities". I wanted to include photographs from both Venices, but I did not want simply to present them side by side. I began to pair off certain of the images from each of the portfolios, placing one on top of the other. One essential rule guided the pairing: to find a gesture, a facial expression or some other element which the two images had in common. I was surprised at how many of the images fit together in this way, given that the two portfolios were developed independently and in such different photographic styles. ◇

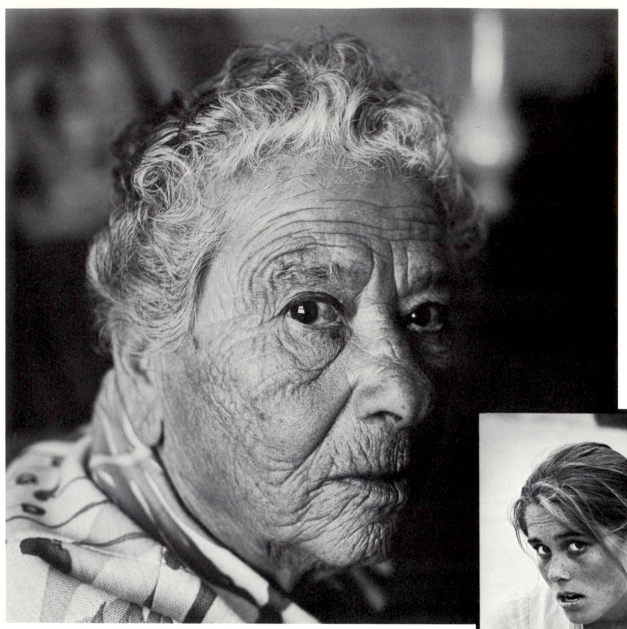
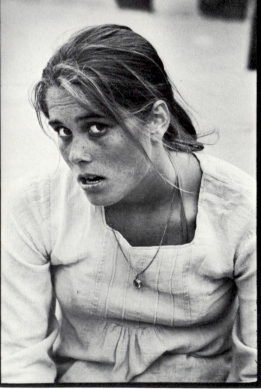

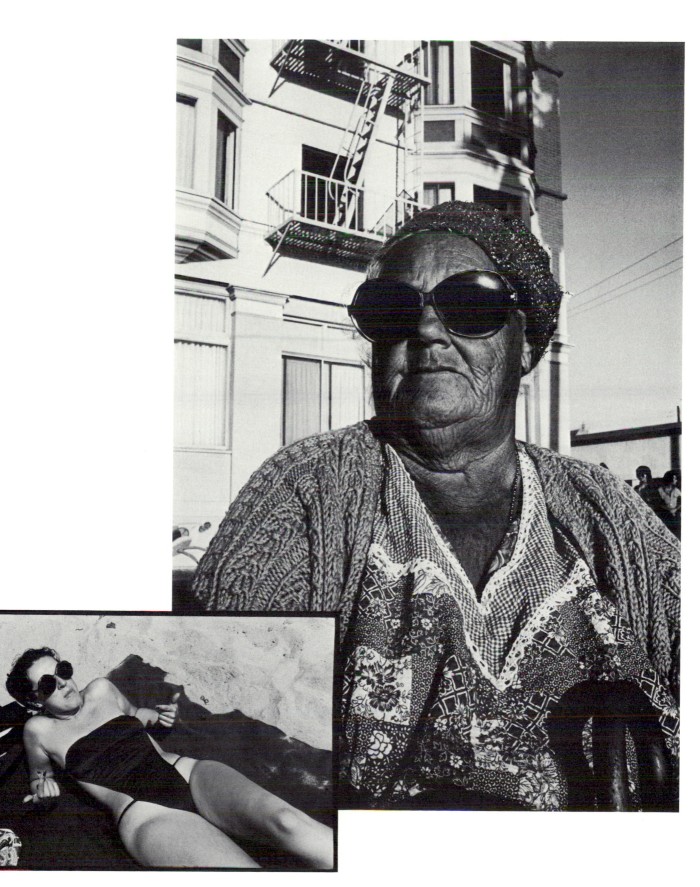

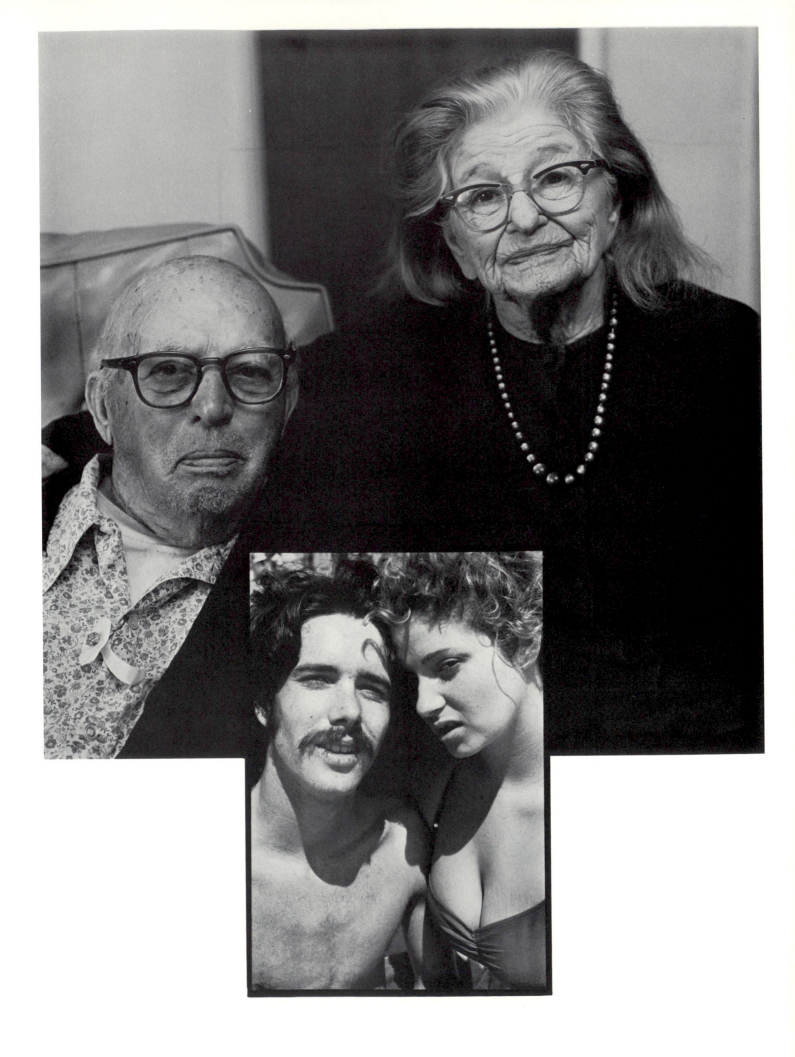

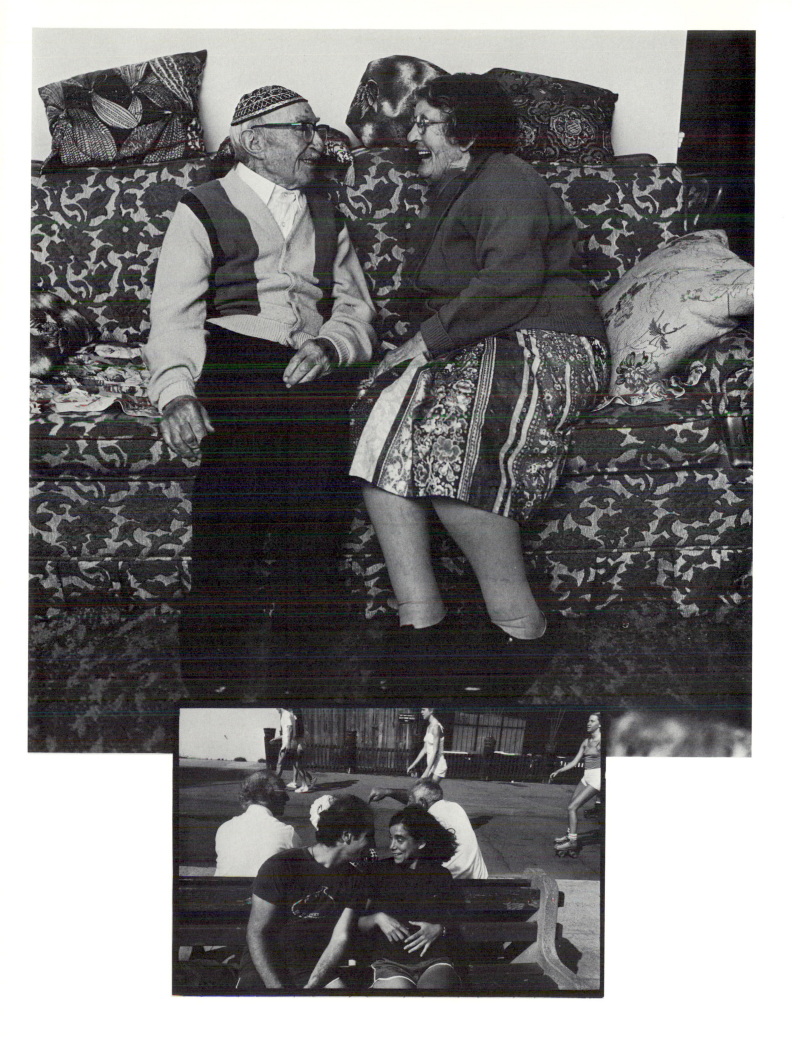

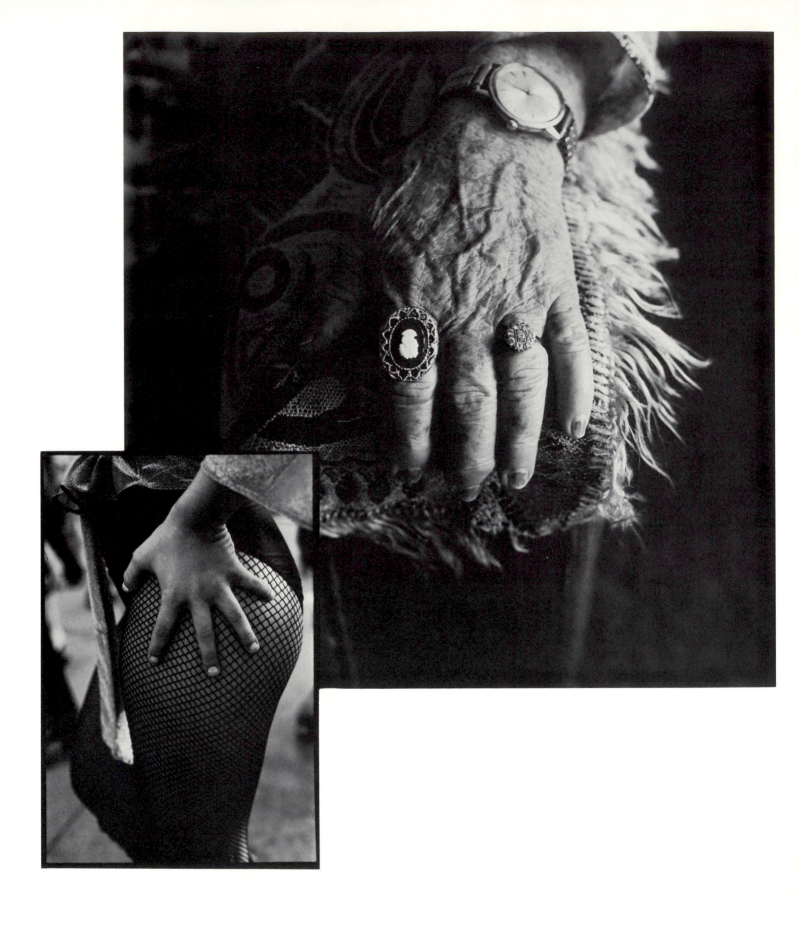

52

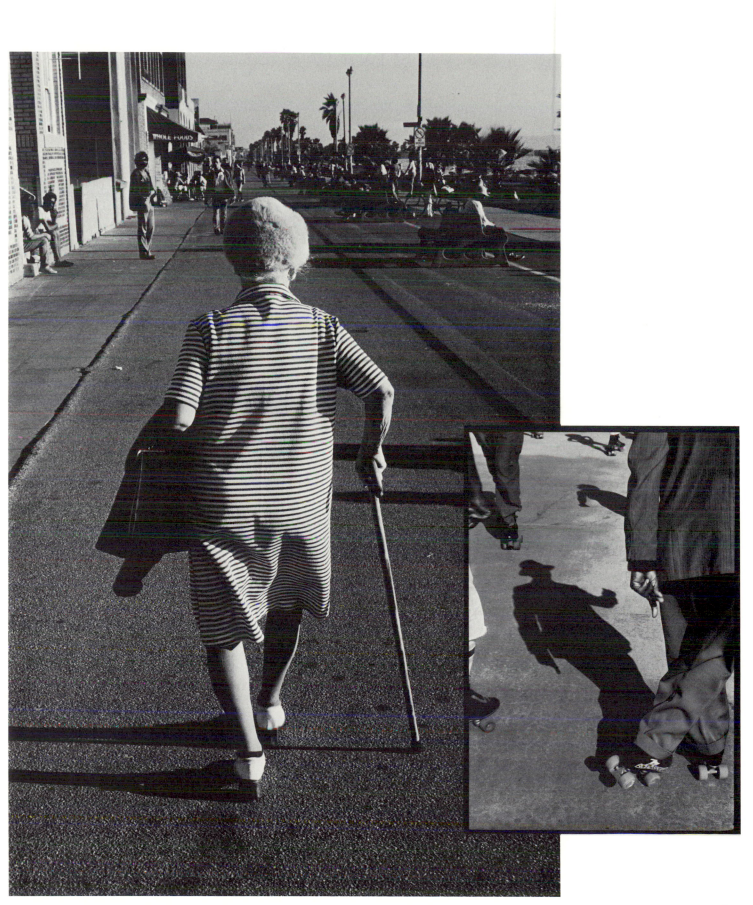

Eduardo B. Viveiros de Castro

Two Rituals of the Xingu*

*Eduardo B. Viveiros de Castro
is a Brazilian anthropologist on
the faculty of the postgraduate
program in social anthropology
of the Museu Nacional in Rio
de Janeiro. He has done field
work among the Yawalapíti of
the Alto Xingu and, in addition,
has studied the surfing culture
of Ipanema. These photo-
graphs, made during his first
trip to the Xingu, not only make
the points emphasized in his
own text, but also illustrate the
hazards of anthropological re-
search: the women of
Mehináku really did beat him.
HSB*

I made these photographs from August through November
of 1976 and in July of 1977, in the *Parque Indigena do
Xingu* (Mato Grosso, Brazil), while doing anthropological
field work among the Yawalapíti, an Arawak group of 120
people. It was my first experience as an anthropologist (I
was working on my master's thesis) and one of my first as a
photographer. I took these pictures to capture aspects of
Yawalapíti life I could not reproduce in written language,
and to show the aesthetic side of *my* perception of them,
my *pleasure* in seeing them, difficult to include in an aca-
demic work. Anthropological monographs leave little room
for "non-structural" aspects of the investigator's perception.
On the contrary, they aim to structure that perception: dif-
fuse impressions, aesthetic pleasure or existential despera-
tion are usually communicated orally to friends and col-
leagues, or made into "literature" in the introductions to
the monographs. I prefer to make these sensations public
through photographs.

The Yawalapíti are one of nine local groups—each with a
distinct language and identity—living in the south of the
Parque do Xingu, an Indian reservation created by the Bra-
zilian government in 1961. Since then, the boundaries of
the *Parque* have been redefined and its area diminished, its
territory cut by highways and invaded by agribusiness.
These tribes—collectively, the groups of the Alto
Xingu—have a common cultural physiognomy and form a
society, linked by intermarriage, ritual cooperation and
economic exchange. Linguistic diversity (some villages
speak Tupi, others Carib, still others Arawak) amidst cul-
tural uniformity constitutes a curious sociolinguistic phe-
nomenon, analysis of which is still underway. The groups of
the Alto Xingu must have come to the region from the north
at least 300 years ago. Geography made the Alto Xingu a
natural refuge for groups dislocated from their original terri-
tories by hostile tribes or by Brazilian colonists.

The Alto Xingu is level and relatively fertile, its many
rivers and lagoons full of fish. Its vegetation, intermediate
between the high plains of the south and the tropical forests
of the north, guarantees a diversity of ecological situations
favorable to human life. The Indians of the Alto Xingu live
by growing manioc and by fishing, the meat of land animals
being considered inappropriate for human consumption.
Their villages are circular, with large communal houses
around a central plaza where important ceremonies take
place and where the men meet. The central plaza is a mas-
culine space; the house protecting the sacred flutes, which
women are forbidden to see, stands there.

*Text and captions translated from the Portuguese by Howard S. Becker.

Xingu society consists of nine local groups of flexible composition, linked in a network of communication by footpaths. The rules of residence and the ideology of descent are fluid and unstable, leaving room for political manipulation and individual calculation. Kinship is bilateral, the transmission of property is unimportant, and each village's corporate rights to the surrounding territory are subordinated to the continually shifting composition of its members. Nevertheless, kinship and linguistic identity are fundamental attributes of social identity and each local group has some distinctive economic and ceremonial specializations. The relations between the tribes/villages (today each "tribe" is reduced to less than a village, and some have disappeared, their remnants being incorporated into related villages) are generally peaceful, although a latent hostility appears in negative stereotypes, accusations of witchcraft and ritual competition.

The groups of the Xingu have a common collective identity, which distinguishes them from the Indians who live further north; their classification of human beings, in most of the languages spoken, distinguishes radically between "Indians of the Xingu", "wild Indians" and "whites". The elements which characterize the Indians of the Xingu are various: diet, bodily decoration, an *ethos* which they define as peaceful and reserved, and the cultural knowledge of rituals, of forms of etiquette and of myths.

The ceremonial-mythological system of the Xingu is the most important element for understanding this society, apparently so fluid and unstructured, with no rigid rules of marriage or residence, and with a political system based on bilateral kindreds which make a matrix of factions. The rituals may be intra- or intertribal, and the most elaborate ones are initiation at puberty, the festivals of the spirits which cause illness, and the ceremonies at the death of important people. These are organized as an opposition between the ritual's "host" and the rest of the community (in intertribal rituals, between the host village and the guests). The ritual's "host" must feed the other participants, who perform a service for him by eating the ceremonial food. "Owning" a ritual gives one prestige and demonstrates power; the "hosts" of the most important rituals are men of position. In the life-cycle ceremonies of initiation and death only the adolescents and the dead of important kin groups are the object of elaborate ceremonies, involving the production of food on a large scale and expensive gifts for ritual specialists (singers).

Xingu mythology describes a human creation cycle activated by a demiurge who made the first women from wooden logs. One of these primeval women married the Jaguar, and gave birth to the twin sons Sun and Moon, the creators of present-day humanity and responsible for the separation between humans and animals; they killed their father Jaguar, symbol of natural ferocity and unpredictability. This mythological cycle underlies the most important ritual of the Xingu, *Kwarup*, the festival of the dead. *Kwarup*, which brings together during the dry season almost all the villages of the Xingu, commemorates the recently deceased of each village. During its celebration, the adolescents in the ritual seclusion of puberty are presented to the community, the girls who have recently left seclusion are married, and intertribal battle, the national sport of the Xingu, occurs. *Kwarup* has some characteristics of a second burial; its symbolism is based on the myth of creation: the twins Sun and Moon conducted the first *Kwarup* to commemorate the death of their mother, who was killed by

Yawalapíti youth preparing himself for the festival of the dead, Waurá village. The colored balloons were given by a visitor, and the Yawalapíti use them, a bit ironically, as exotic ornaments. The boy's belt, made of glass beads over cloth, depicts a stylized human figure, a common and important pattern in the Xingu.

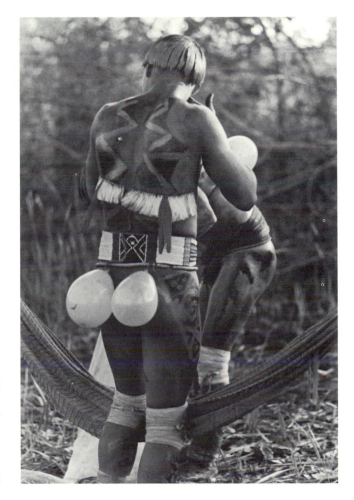

Reproductions of color photographs by Eduardo B. Viveiros de Castro

jaguars, and it emphasizes the impossibility of individual human resurrection. This ceremony of the dead, in which adolescents are integrated into adult life and the girls are married, is also an affirmation of life.

The two other highly significant ceremonies of Xingu society express the separation between the sexes and their latent antagonism. The ritual of the sacred flutes—the *Jakuí*—unites and symbolizes the masculine community of the village (or of the whole society) and women are strictly forbidden to see it. Present-day flutes are replicas of archetypal, mythical flutes, identified with aquatic spirits. The sacred flute complex of the Xingu has something in common with ceremonies of the Amazonian northwest, linked to an ideology of symbolic masculine fertility, guaranteeing men's power over women. The women, in turn, display and represent themselves through *Yamurikumā*, the festival of the "women-monsters", mythological creatures who abandon the village of their husbands and form a mono-sexual society. During *Yamurikumā* (the name of both the ceremony and of the collective feminine spirit which can cause illness in men and women), the women temporarily "take power", occupying the village plaza and attacking men who come near them. Just as the *Jakuí* has a solemn and sacred tone, and its basic symbolic practices are *prohibition* and *reserve*, the *Yamurikumā* is staged in the style of *Carnival*, festively, and its symbols are feminine *licentiousness* and semi-ritual *aggressiveness*. To make an imperfect parallel with the ceremonies of Brazilian society, we could say that *Kwarup* is a civic ceremony (affirming the pan-Xingu identity), *Jakuí*, a sacred ritual, and *Yamurikumā*, a carnival.

The celebration of *javari*, Waurá village. The Yawalapíti men and guests paint themselves at dawn in a camp near the Waurá village. This *javari* is celebrated to commemorate the death of an old champion in a competition consisting of throwing blunt darts from a short distance at the legs of the opponent. (There are always two opponents, who may protect themselves behind a sheaf of sticks which does not protect the entire length of the body; the player at whom the dart is thrown must avoid it without lifting his feet from the ground.) The celebration of *javari* always involves just two villages and takes place in a climate of tense expectation; it is the ritual nearest to war, say the people of the Xingu. The relation between the opponents is modeled on that of "cross-cousins"; they use that kinship term to describe their opponents. The body decoration of *javari* is, by Xingu standards, "disordered" and carnivalesque: each person tries to outdo the others in originality and brilliance.

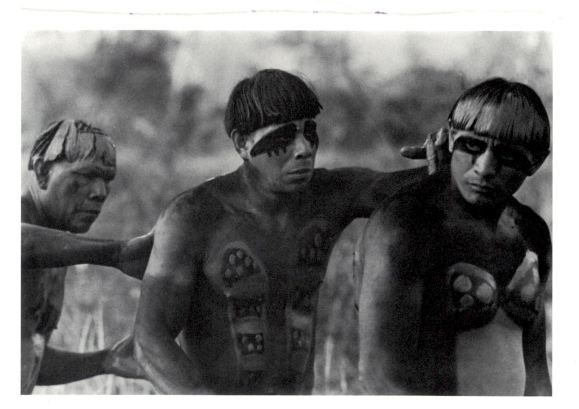

Three Yawalapíti men paint themselves for the festival of the dead, Waurá village. The black paint (charcoal) on the eyes represents a bird of prey, and the highly stylized painting on the chest and arms represents snakes, fishes and insects.

Decoration for the celebration of *javari:* the Yawalapíti prepare themselves to enter Waurá village. They carry throwing darts and a dart thrower in their hands.

The connection of the groups of the Alto Xingu to the national society is quite different from that of other indigenous Brazilian groups. For various reasons—the political action of certain *indigenistas* of humanistic vision, the inaccessibility of the region to white penetration, and the absence of products whites want—the societies of the Xingu have succeeded for some time in avoiding the common fate of the immense majority of indigenous groups whom the frontiers of Brazilian expansion have reached: death from epidemics or massacres, the plunder of their lands, semi-slave labor for mining companies or agribusiness. Protected by the *Parque Indígena,* the tribes of the Xingu until recently received assistance from the Brazilian government, which was exceptional compared to the disinterest and negligence earlier governments and regimes had always displayed with respect to crimes against the Indians. Today, political changes in the definition of the ''native question'' are putting societies of the Xingu in the same situation as their brothers of other tribes: the myth of the *Parque do Xingu* is crumbling, and the government seems to have little further interest in preserving the *Parque* as a showcase for official native policy.

A line of dancers in Yawalapíti village. The little girls also take part in the ceremony, in a somewhat disorganized way. Like all ceremonies of the Xingu, *Yamurikumã* does not have a well-defined beginning or end, and is composed of a series of more or less climactic moments. This ceremony was organized when an important woman of the village, made sick by the spirits of the *Yamurikumã,* decided to perform the ceremony in order to be cured.

Visitors from another Xingu village being beaten by Yawalapíti women. The man in the white shirt is being protected by a village inhabitant. The most violent attacks are on strangers, the men of the village normally being attacked in fun, usually by tickling and pulling their genitals. The man in the military cap is the chief of the Yawalapíti village, who is pretending to try to obstruct the women attacking the visitor; in fact, he is enjoying himself immensely.

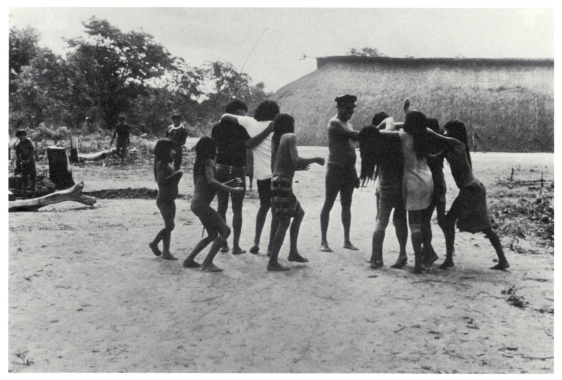

For a long time the Parque do Xingu played a funda-
mental ideological role. The Indians of the Xingu were
always the most photographed, filmed and visited of all
the Brazilian Indians; they are conspicuous in illustrated
books for tourists about exotic Brazil, on postcards and in
stereotypes of the mass media. Thus, the "protection"
given the Indians of the Xingu—the federal guarantee of
the right to self-determination and to the possession of
their lands—served as an alibi, disguising the misery and
plunder suffered by other Brazilian Indians. If this helped
the Indians of the Xingu themselves—after all, it is better to
be visited by the King of Belgium or photographed by
Japanese tourists than killed by a *fazendeiro* or have your
land expropriated by a multinational mining company—it
nevertheless gave a distorted picture of the Indians' real
situation. Now, with the *Parque do Xingu* in danger of
disappearing in the face of official indifference, things will
certainly get worse, and the presence of the whites will no
longer be confined, as in the pictures I took, to colored
balloons, glass beads and hunting rifles. ◇

Waurá girl, watching the
Yawalapíti visitors.

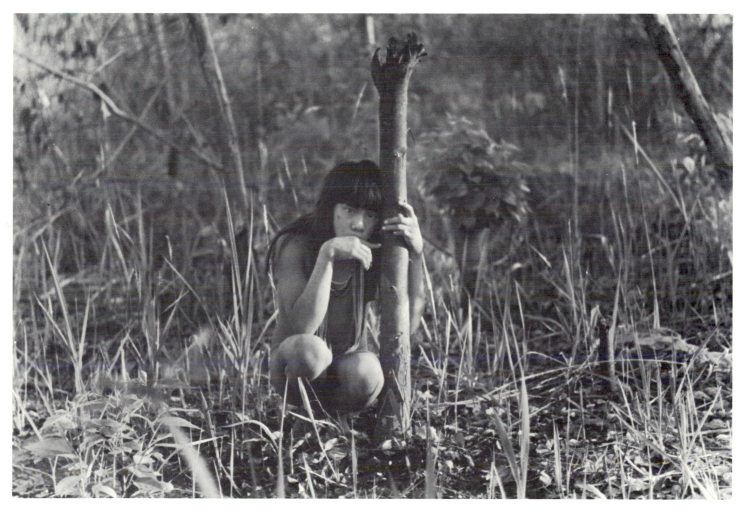

Karin B. Ohrn and Richard P. Horwitz

Karin B. Ohrn and Richard P. Horwitz are Associate Professors at the University of Iowa. Karin is in the School of Journalism where her teaching and research focus on photography and visual communication. She is the author of Dorothea Lange and the Documentary Tradition (Louisiana State University Press, 1980). Rich is in the American Studies Program where he focuses on ethnographic fieldwork and methodology. He is the author of Anthropology Toward History: Culture and Work in a 19th Century Maine Town (Wesleyan University Press, 1978). The material presented here is part of a larger collaborative effort begun in 1979, to be presented in a book now in progress, The Strip: An American Place. HSB

Mac's and Mil's

Few nations can rival the United States for sheer variety of landscape. Popular and fine arts, literature and lore represent a proud montage of plains, deserts, tropics and woodlands. The landscapes that Americans have built show similar variety though less pride. Probably none has evoked as much outright disdain as urban slums and their roadside equivalent, the "strip". Glaring lines of fast-food joints, motels and gas stations are the ghettos of commerce.

For all but a few pop artists and developers, the strip has come to represent variety gone wild—blinding, angular clutter. Even as patrons welcome the services a strip provides, they complain that it all looks so alien. Individual businesses are homogenized at Franchise Central but relate to their neighbors like pinball machines in an arcade.

Given this popular impression as well as changing economic and environmental conditions, franchisers scurry to encourage less "plastic" structures, and planners to "nucleate" them in tidy malls. They think that themes, barnboard and plants will provide a more rational and truly satisfying environment than the strip, assuming that the way the strip looks to consumers is its chief fault.

We must pay attention to a strip's use as well as its look and to workers as well as consumers. Surely their satisfaction is as important as any. We believe, further, that our assessments must be grounded in detail. We focus, then, on a strip in Coralville, near our home in Iowa City. Like any site it has its share of unique qualities, but it has a typical look, history and reputation. In local humor, particularly among "University (of Iowa) types", the Coralville Strip assumes a role elsewhere reserved for Cleveland, Orange County, and the state of New Jersey.

We reject the stock critique. When you examine the strip from inside, attending to action as well as vision, the movement from strips to malls and greenery resembles the history of the strip itself. If we are right, modern alternatives to the strip, though costly in natural and human resources, will be no more satisfying than the original, and consumers boasting "visual literacy" and good taste must share the blame.

Here is a bit of the photographic record we use to discover, document, and illustrate themes in the history of the strip that are crucial to our interpretation. For Karin, who made these photographs between 1979 and 1981, it was a particularly difficult assignment. The pictures should recreate specific sites but invite generalization. They should toe the line between local color and archetype. They should confound a purely visual critique with visual evidence. You will have to decide for yourself how well we do, but our presentation closes with some self-criticism.

Mil's building is bordered on one side by a car dealership and on the other by her gravel parking lot and a bakery. A patron's pickup truck noses to the front.

Mary Wilson takes an order at the counter.

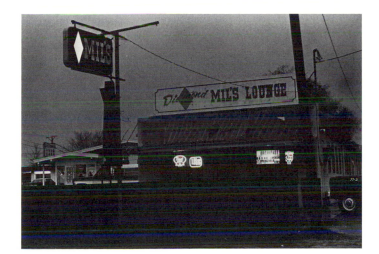

The Coralville McDonald's is on First Avenue, locally known as "the new strip". The store is brand new with lush landscaping and Tudor ornamentation. It is close enough to a state-of-the-art store to be mistaken for those featured in national advertisements. Whatever your opinion of McDonald's or franchises, this store represents some of the most modern and sophisticated attempts to satisfy consumer tastes.

Diamond Mil's is an owner-operated bar serving irregular meals and regular country-and-western music to a much more limited clientele. Millie has rented the building, a converted mattress factory, for more than ten years on Highway 6/218, the original Coralville Strip. As with McDonald's, we anticipate some stereotypes— in this case from cute features in the Sunday paper and other nostalgia, but Diamond Mil's is the sort of ma-and-pa operation that once dominated the strip.

Obviously, neither business literally represents anything beyond itself. They have distinct histories of providing different services to different people on different sites. Each is modern and successful in its own way. But look at McDonald's as a sign of the present and compare it to the past that Diamond Mil's suggests. In the differences are some lessons on the strip.

Despite great differences in their trade and organization, McDonald's and Diamond Mil's share success on the strip. They contribute substantial services, wages and taxes to a diverse citizenry. A large portion of their receipts turns directly over to neighboring suppliers, utility companies and banks, and indirectly to nearly every other sort of enterprise. Both provide a haven for motorists wearied by workaday life and highway travel.

But the differences are substantial and represent well the direction of commercial development along the strip. McDonald's has rationalized nearly every phase of service delivery. The decor; the equipment; the products; the routines, appearance and manner of employees have been engineered to their effective limits. In the store you, the customer, come first, no matter who you are. Diamond Mil's, on the other hand, shows more spontaneous compromise. With noticeably limited resources, the owner, employees and patrons improvise on personal tastes.

These two businesses, then, suggest the larger motion of American culture from individual to corporate enterprise, from community to society. As the strip evolves from Mil's to Mac's (and thence to malls), it recapitulates the history of the industrial sector, from shop to factory, with equally mixed consequences.

Such parallels are too grand to develop, much less prove, in 20 photographs of two sites. Moreover, the two are somewhat deceptive representatives. McDonald's is a well-recognized leader in its field. It is not so much typical of the modern strip as of the avant-garde. Nor is Diamond Mil's simply a relic, a survival of yore. The conditions surrounding its origin have changed substantially. More well-heeled establishments may, in fact, help secure a limited place for blue-collar bars. It is we, then, who *make* these places representative.

Obviously, too, the photographs are made. Nothing wills itself onto film. With the permission of our subjects, we composed, selected and arranged photographs to portray the sites as accurately as possible but also to make a point. In some cases, particularly in the McDonald's sequence, we replaced our first choice to obtain subjects' consent. But in even more cases, we selected pictures that would advance our point, even where that meant some compromise in technical quality.

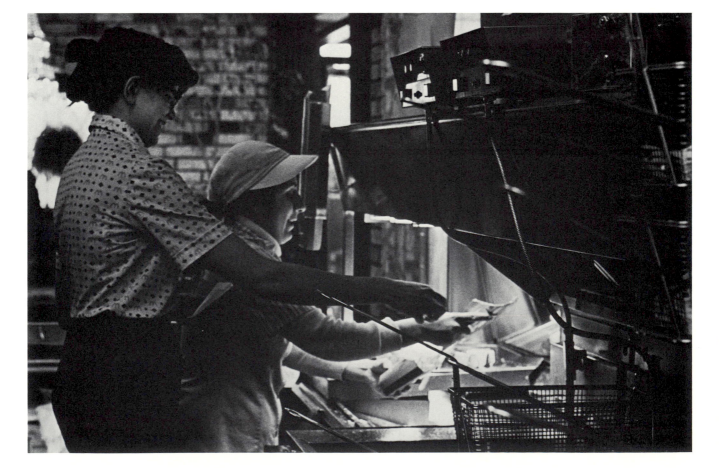

Sara Weers helps Farokh
Roberson work the fry station.

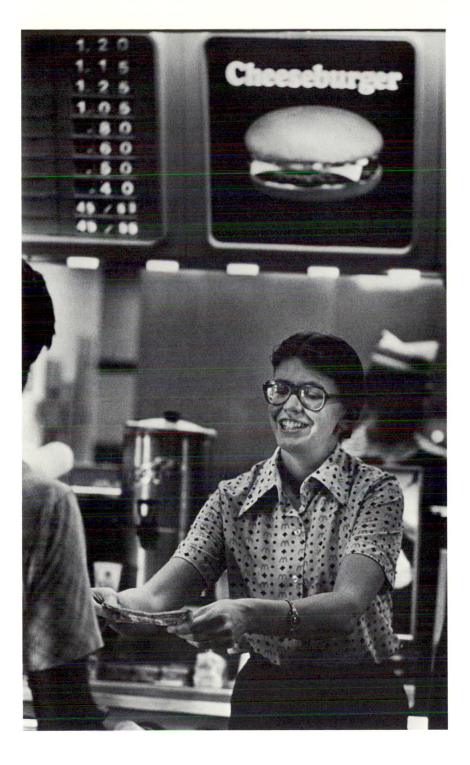

But technical considerations also affect the presentation. These are fairly conventional documentary photographs, even if of somewhat unconventional subjects. There are the obligatory establishing, detail, portrait, interaction and closing shots as well as exposures and distances. The use, insofar as possible, of a normal lens and available light reflects canons of photographic realism as much as anything in the subjects themselves. McDonald's appears more angular, tidy and metallic, in part because it is simply better lit. The bar is dark enough to necessitate more grainy and hence softer images. Black-and-white film obscures some of the dreariness in Mil's decor and the gaiety in McDonald's.

"Ma" Millie Ollinger, the owner and operator, does some book work at a table under one of the black velvet paintings that decorate the walls.

But the most serious potential for bias lies in our approach to the two sites. We spent considerably more time in Diamond Mil's than in McDonald's. The photographs of Mil's were made during and following more than a year of observations and interviews in the bar, where we enjoyed unlimited cooperation. The McDonald's pictures were based on an assignment: "Get shots that show regular tasks and contrast workers' and consumers' points of view." There were minimal background or follow-up interviews because of time constraints in our schedule and because of contextual constraints suggested by the management.

On February 28, Bruce Nelson (far right) celebrates his birthday with cake and beer. Sharing them (seated to his right) are Jeanie Rummelhart, whose husband just left to get more beer, and the Aubrechts, while Mr. and Mrs. Housel and a little one look on.

Theoretical, technical, strategic or unnamed factors may significantly bias our presentation, but we doubt it. The photographs still show much of the truth. The contrast between cast iron and stainless steel suggests simplicity turning into high technology; between workers who touch their customers and those confined to stations and uniforms, advancing social stratification; between eclectic decor or celebration and omnipresent advertising, management replacing personal expression.

Together, these suggest that we find an alienating future foreshadowed in McDonald's. This is not a bias but an opinion. Diamond Mil's has a warmth and spontaneity that no amount of engineering, smiles, themes, barnboard or plants can recreate. The key ingredients are people who truly care about themselves and each other, who are able and willing to tolerate inconsistency and inconvenience to show they care.

This is not to counsel a halt to progress, much less a return to the past. Even if such a retreat were possible, there would be significant losses. Whatever their faults, giant corporations like McDonald's have helped raise the standards of quality, cleanliness and fair play on the roadside. Look again at Mac's and Mil's, and ask yourself: Which is more likely to guarantee a dependable product? affirmative action hiring practices? access for the handicapped? Which is less perilous for an investor or physically exhausting for a worker? As much as McDonald's portends spiritual impoverishment, it promises material rewards.

These photographs, then, show a legacy of the strip remarkably like the legacy of American society as a whole. In the exchange of goods and services, truly human and material benefits are still to be found, but the balance between them seems in peril. Insofar as both sorts of rewards are to be prized in the future, we will have to look beyond the strip's stock critique and the purely cosmetic, consumer-oriented reform it implies. Waste and ugliness are surely worth combating, but, before we turn our business districts into massive McDonald's, we have much to learn from both Mac's and Mil's. ◇

Charles Berger

*Charles Berger majored in sociology as an undergraduate and worked in the research department of an advertising agency before deciding to devote himself full time to photography. He has for some years experimented with color processes, making his own color separations in order to achieve greater control. He has published two books which apply these processes to the study of societies. *Image Tibet *is a collection of single images, solid colors applied to visually simplified photographs. *Flamenco Gitano, *from which "A Palo Seco" is taken, is an experiment in characterizing a society by focusing on short episodes, letting an event which took perhaps 15 or 20 minutes epitomize some important social phenomenon, as this episode lets us see how a performer serves as a local hero. The images are completed by the verses of flamenco songs, presented both in Spanish and in an English translation by Chris Carnes "Cristóbal". HSB*

Flamenco Gitano: A Palo Seco

After singing and dancing for 36 hours, Miguel Funi comes home on Sunday morning to have a few drinks with friends at the Bar Pasaje in Lebrija

These are photographs of the music of the gypsies living in Spain. Among the gypsy people, only Spain's *gitanos* have evolved an art form that reflects and cultivates the passionate lives and oftentimes tragic deaths that characterize the gypsy cultural experience. For it is in the music of *flamenco* that the *gitano,* bereft of written language or history, can evoke the heritage of his blood through the experience of *duende,* where all becomes spirit. Such expression and experience of *duende* is the goal of the *flamenco* artist in creating his music, as it has been the focus of my camera and the intent of this work. ◇

I don't want to love anyone
nor do I want anyone to love me
I want to be among the flowers.
Tomorrow I'm going there.

What bad luck I have
wherever I go
an evil star guides me.

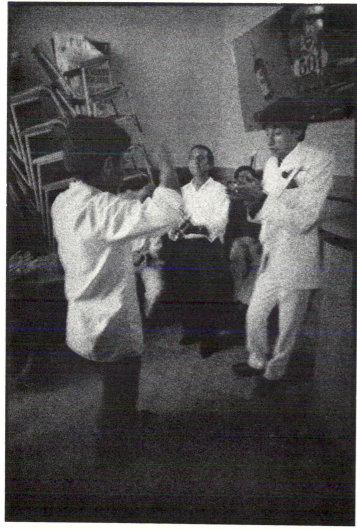

No quiero quierer a nadie
ni que me quieran a mí
yo quiero estar entre las flores.
Voy a ir mañana ahi.

Que mala suerte es la mía
por donde quiera que ando
que mala estrella me guía.

Reproductions of color photographs by Charles Berger

Give a small offering
to the poor gypsy
give it to him for God's sake.

Get up and stop sleeping
the little birds are coming
singing at the dawn.

You said you didn't love me.
With one hand you threw me out
with the other you pulled me back.

Darle la limosnita
al pobre gitano
darsela por Díos.

Levantage y no duermas más
porque venia los pajaritos
cantando la madruga.

Que no me quiería
dice que no me quiería.
Con una mano me hechaba
con la otra me ha recojía.

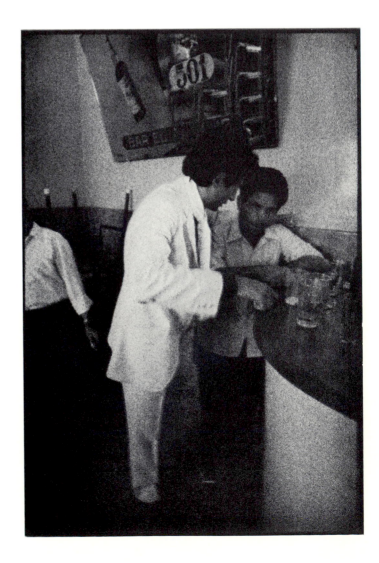

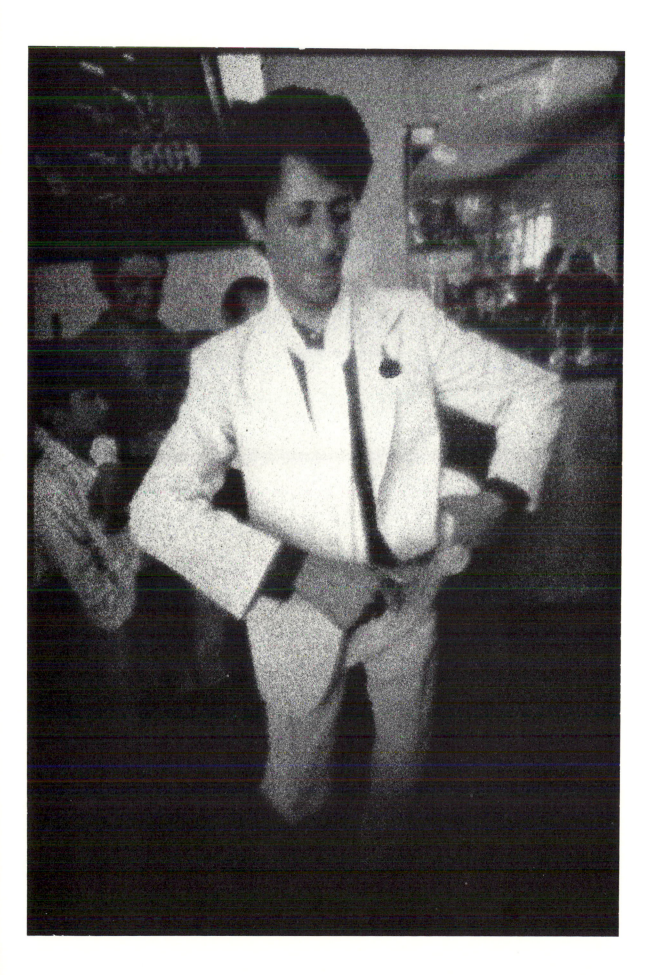

I tell you in my singing
and I tell you in my dancing
of the troubles I'm going through.

I'm going crazy
crazier by the day.
I have had the boldness
to give my love to all women
at the same time.

History has said that
he who dies loving
goes straight to heaven.

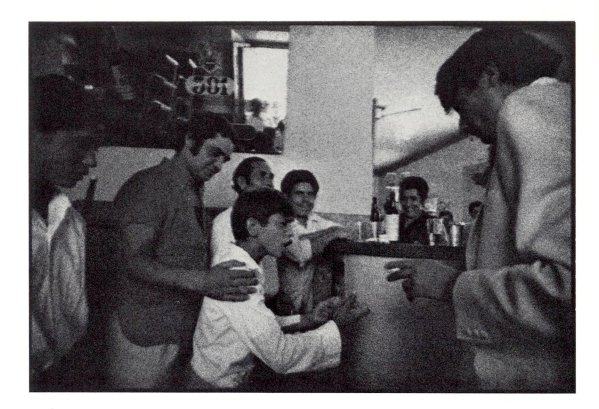

Yo te lo digo cantando
y yo te lo digo bailando
de las penitas que estoy pasando.

Mas loco mi vi a volver
mas loco me estoy volviendo
he tenido el atrevimiento
que entregé mi querer que a todas mujeres
al mismo tiempo.

Formen historia de que
aquel que se muere quieriendo
va derechito a la gloria.

Euan Duff

Euan Duff, a British photographer, has experimented with a number of ways of presenting his conclusions about contemporary society. I cannot improve on his own description of his career. HSB

Working World

I have been involved in photography now for some 23 years as a student, a professional and a teacher. Throughout my career I have had a view of photography derived, it would seem, from *Picture Post*. During childhood the magazine provided me with a formative view of the world, a world represented by photographs which seemed to value ordinary human experience and were flavored by the particular political optimism of their time. *Picture Post* folded just as I started working in photography. My belief in the political vitality of the medium was not popular with clients; so after free-lancing as a photojournalist for five years, I gave up the struggle, took a teaching job and continued to work on my own. I produced a series of handmade portfolio books of my photographs which led, six years later, to the publication of my book *How We Are.* I continued to work; had two exhibitions; published another book, *Workless,* this time with a sociologist; and made a film of my still photographs before I realized that I was not being understood. A handful of people were enthusiastic about my work, but the world at large, including the photographic world, did not begin to understand what I was doing. I could see by this point that all of my published work was badly flawed, but still did not feel that my fundamental approach was wrong— my view of photography remained the same. Consequently I re-edited all my earlier work into a series of shorter sequences, of which the sequence presented here is one, leaving the more effective and putting them into contexts which made more sense to me. The work became more personal and yet, I hoped, also more accessible to anyone wishing to look at it carefully. I thought about a text, about trying to explain to people what I was attempting to do, but realized that any linked text would interfere with the very photographic quality that I was trying to generate; so instead I wrote the following notes about the medium of photography itself.

The power of photography seems to derive from the power of vision itself, an almost primeval power referred to in the Bible when the serpent told Eve, "For God knows that when you eat of it your eyes will be opened, and you will be like God, knowing good and evil." It is a power that mankind has acknowledged ever since the first images were made, since people first attempted to represent what they could see realistically, a power inherent in photography.

Photographs are only straightforward optical representations of the external world, and the accuracy of the process provides the medium with a fundamental paradox that its realism, its root characteristic, is also the source of the widespread and false belief that photographs cannot "lie", that they only verify what actually exists and that the role of the photographer is therefore quite minimal.

However, the mechanical nature of the medium does limit the range of techniques and visual effects available to photographers, and although the content of a photograph is obviously determined by the choice and treatment of subject matter, the basic design of the range of photographic tones or colors within the image is largely determined by the process, and is a direct consequence of the exact physical/optical relationship between image and object, between the camera and the subject.

The most unique and important facility of the medium, though, is its ability to freeze a moment, to record minute instants of time. It is this facility that has allowed photographers to explore the most interesting facets of human experience and to produce their most effective work, work that exploits the fact that spatial relationships between moving and static objects change in time, and that as they change, so they affect how those relationships can be understood.

It is by selecting particular moments in time from particular viewpoints in space that photographers can actually interpret human experience rather than simply illustrate it, and by doing so with vital enough subject matter they have provided us with some very profound responses to the human situation in the 20th century. Unlike film, still photography has produced documents which can be contemplated; and unlike other more traditional arts that have, under the modernist influence, been reduced to contemplating themselves, photography has allowed us to study the experience of others, even if this has been selected and interpreted by the photographer, and reduced by the process.

It seems paradoxical that photographs are most interesting when they appear the least contrived. It is as if we want to pretend that we are in some way looking directly at an event, when we know that we are actually looking at a photograph. To make sense of the paradox we need to recognize that taking photographs can be a deliberate and intentional act and that considered as such, the pictures can become more interesting. We then have to ask of any photograph why it was taken, and we look for significance in those clues which could reveal the photographer's attitude to the subject. Those clues exist within the precise detail of the photograph, the detail affected by the photographer's choice of an exact point of view and an exact moment of exposure.

A dialogue then exists between the particular detail and the general significance of the photograph, and is heightened when we cannot be sure that our interpretation is correct, the photograph remaining open, ambiguous and most interesting. Any interpretation then has to fit the feeling of the photograph as well as the facts.

Another popular misconception about photography is that the individual print is the final product of the process. This belief obviously links with ideas about painting; but whereas painting can be a complex, multi-technique process, capable of communicating in many different ways at many different levels, photography is a simple technique producing facile images which can only operate on a single plane. The media have always used it as such and have assumed that photographs could only contribute to more

complex messages if they illustrated written articles or captions, an assumption that is obviously true of most "applied" commercial photographs but which has prevented more open or "pure" photographs from being understood in the terms that I have described.

The art world, used to dealing with painting, and the media, used to dealing with writing, have therefore largely misunderstood the true nature of photography as a medium in its own right, whereas photographers have actually been most effective in communicating to the general public by publishing and sometimes exhibiting collections of their work.

Presented with minimum captions or text, the collected work of the world's best photographers provides us with the medium's most convincing proof, as well as evidence of its potential. The vital interpretive clues within each photograph are complemented, reinforced, questioned or challenged by those contained in other photographs presented alongside. Use of sequence allows far more complex ideas to be introduced, with no loss to the photograph's natural ambiguity. One set of possibilities is simply related to others in a way which allows photographers to communicate more specifically, seriously, and even profoundly, than they ever could with single images.

Photography, then, is a mechanical process crucially dependent on a single human decision. The process produces single images which are, again, crucially dependent on the context in which they are seen. Photographs might appear to be self-evident but they are more often open, incomplete and ambiguous, and to make sense of them they need to be seen with words or with other images.

I have, throughout my career, been concerned with the construction of these artificial contexts, in particular with using photographs in sequence, because by so doing I have extended the possibilities of the medium, making them more akin to those of poetry than to those of painting or of journalism.

Bertolt Brecht wrote: "Less than at any time does a simple reproduction of reality tell us anything about reality. A photograph of the Krupp Works or GEC yields nothing about these institutions. Reality proper has slipped into the functional. The reification of human relationships, the factory, let's say, no longer reveals these relationships. Therefore, something has actually to be constructed, something artificial, something set up."

The sequence "Working World" includes photographs taken at different periods throughout my career and begins by showing some of the traditional types of work environments, which are then compared with some of the more modern. These lead into photographs of the home, of domestic and leisure situations, which culminate in a photograph of an old persons' home.

The title, like the photographs, is ambiguous, though the sequence is concerned with questioning how the nature of a work experience might affect other aspects of life. Some of the photographs are of the unemployed, first used in my book *Workless*, but does the differentiation of work, unemployment and leisure as separate experiences actually help us to understand their relationship to the quality of our lives in general? ◇

Law in Zinacantan, Mexico

Frank Cancian

Frank Cancian was a press photographer before entering Harvard University, where he received a PhD in anthropology. He did his research in Zinacantan, a village in Chiapas, and has returned there several times over the years. He made photographs during all his trips, and many of the books from Harvard's Zinacantan project are illustrated with his pictures. In 1974, he published a book of photographs, Another Place (Scrimshaw Press), of the village in Chiapas. He has here assembled a number of images which depict the legal process in Zinacantan. HSB

These photographs show formal dispute settlements and related activities among the Maya Indians of Zinacantan, Mexico. Zinacanteco judges sit on benches on the veranda of the town hall, and cases are brought before them. The judges discuss, mediate and placate—as do the mayor and the other elected officials who sit with them. They all seek to establish calm among community members rather than to determine the balance of abstract justice. Good settlements leave both parties satisfied.

In 1971, when the photographs were taken, there were about 11,000 Zinacantecos and a handful of non-Indians living in the township (municipio). Zinacantan, the place, covers an area of 117 square kilometers and includes more than a dozen hamlets spread over mountain valleys and hillsides at elevations between 5,000 and 8,000 feet above sea level. Zinacantecos, the people, are distinguished from their Indian neighbors in other townships by self-identification, and by the distinctive costume they usually wear. They are related to other Indians in the highlands of the state of Chiapas who also speak the Tzotzil language and to the many other speakers of Mayan languages throughout southern Mexico, Yucatan and Guatemala.

Their municipio straddles the Pan American Highway as it goes from the hot, lowland state capital of Tuxtla Gutierrez to the highland city of San Cristobal de Las Casas. Most of the roughly 25,000 residents of San Cristobal speak Spanish and identify themselves as Ladinos (non-Indian Mexicans), but the city is surrounded by more than 200,000 Maya Indians living in about a dozen municipios in which they numerically dominate the Ladinos. For most of these rural highland people San Cristobal is the point of contact with international commerce and the official world of politics and government. Thus, Zinacantecos and the other Indians of the Chiapas highlands live apart from, but connected to, Ladinos, Mexico, and the modern world.

Jane Collier, who has written extensively about law in Zinacantan, reports* that court officials looked puzzled and gave inconsistent answers when asked what they do when someone commits a crime of a specific type. She observed, "They didn't do anything. Their job was to wait for a plaintiff to state his wishes and then to try to suggest a compromise solution acceptable to both sides." After a year of collecting data on Zinacanteco legal concepts and witchcraft beliefs Collier abandoned a search for Zinacanteco "laws" or rules that govern sanctions and concluded that "Zinacantecos were not concerned with crime and punishment. They cared about ending conflict, to forestall supernatural vengeance." ◇

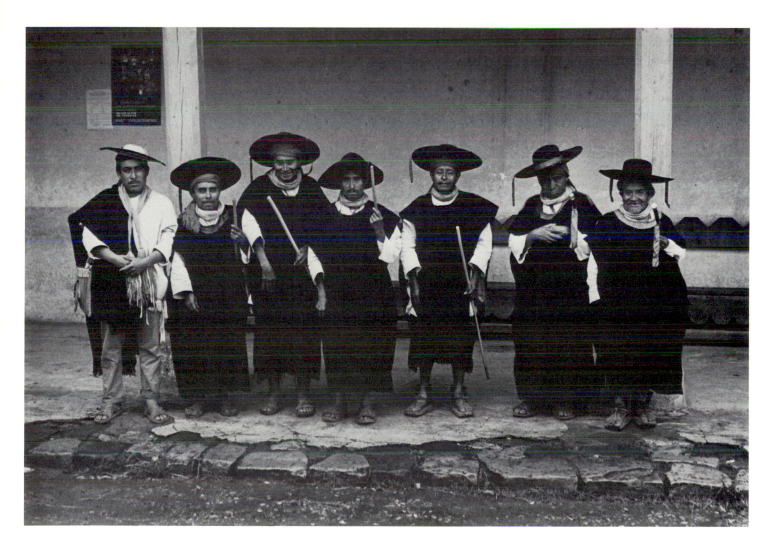

* These remarks are from the preface of Jane Collier, *Law and Social Change in Zinacantan* (Stanford: Stanford University Press, 1973). Evon Vogt has published two general books on Zinacantan, *Zinacantan: A Maya Community in the Highlands of Chiapas* (Cambridge: Harvard University Press, 1969) and *The Zinacantecos of Mexico: A Modern Maya Way of Life* (New York: Holt, Rinehart and Winston, 1970).

The photos show younger men hearing petitions of younger and older people. In Zinacantan, as in most places, older, more experienced people are usually sought to help settle disputes and establish justice; and the hamlet leaders who function "below" the municipal court are usually older. The unusual arrangement of the official court reflects a contradiction between the local system and the larger governmental structure, not a perverse Zinacanteco cultural preference for the wisdom of youthful inexperience. Schools in the area have expanded, and each succeeding generation of Zinacantecos is more educated in Spanish. Today most young adult men and many young adult women speak Spanish. When reforms of municipal administration throughout the state took place in the 1950s and 1960s, it became ever more important to have municipal officials who could meet the demands of outside authorities and thereby better serve the interests of the people of Zinacantan. Thus youth has come to dominate the official civil administration of Zinacantan.

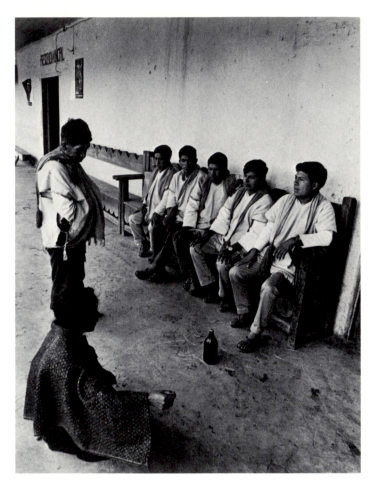

The turbaned elders shown greeting the mayor and his compatriots are senior religious officials who are serving one-year terms. They administer the elaborate system through which men sponsor religious fiestas. Each of them sponsored fiestas for at least two years to make himself eligible for his present high post.

Once these elders had civil authority, too, but changes dictated from outside Zinacantan eliminated the civil power and authority their predecessors had. They retain only religious duties, the respect of the community, and a bench on the veranda of the town hall.

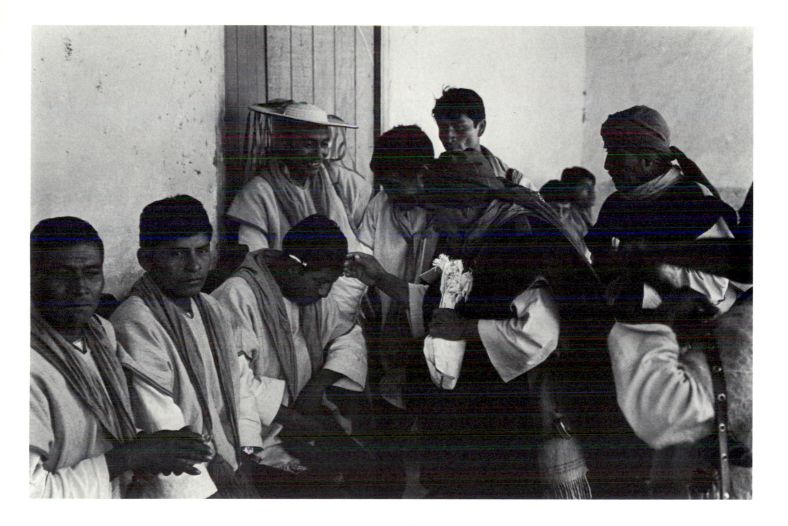

The jail that is built into the
town hall is used mostly as a
"cooler" for drunks, and occa-
sionally to hold prisoners who
will be sent to higher courts
outside of Zinacantan.

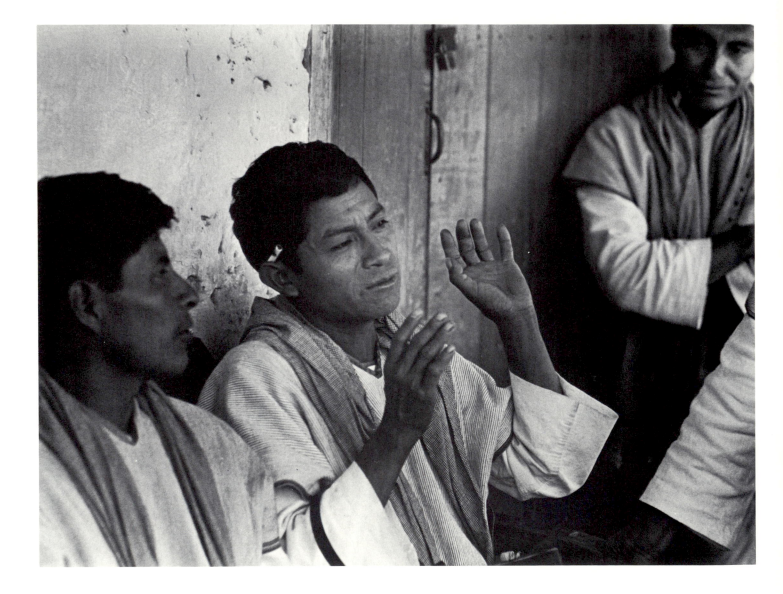

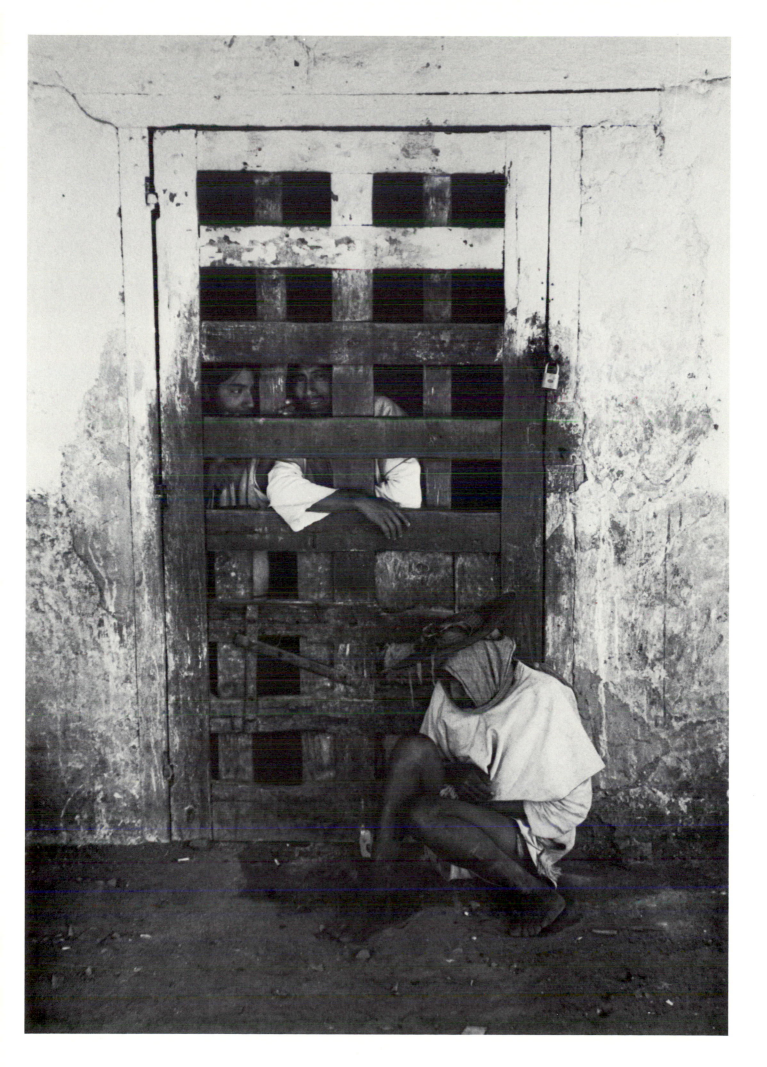

Douglas A. Harper

Douglas Harper received a
PhD in sociology from Brandeis
University and now teaches at
the State University of New
York in Potsdam. His disserta-
tion was a study of tramps, mi-
grant fruit pickers who hitched
rides on trains from one job to
the next. He did his research by
"riding the rails" with them
over a period of several years, a
risky venture, the danger of
which was increased by his de-
sire to photograph what he was
learning about. He believes
strongly that the basic working
unit of visual sociology is text
and image as an indivisible
whole, that the long narrative
accompanying these photo-
graphs informs them just as it is
illuminated by them. HSB

Carl
I found the longest section of train and began walking its
length. I walked down the narrow canyon between the
cars and came upon a tramp crouched near the door of
the first empty boxcar. He did not see me coming and
looked angry when I suddenly appeared. He smelled of

booze and sweat and urine and his work uniform looked like he'd slept in it for a week. His face was scarred and unshaven. He had some gear back in the boxcar so I asked him where he was headed. It was clear he wanted nothing to do with me but he answered that he was going west to pick apples. I told him that I, too, was going to Wenatchee to pick apples but he answered that there wasn't any good work in *Wenatchee,* you had to go north, up the Okanogan to a place like Oroville. Before I could ask him where that was he'd slunk back to the corner of his car. I walked on to find my own.

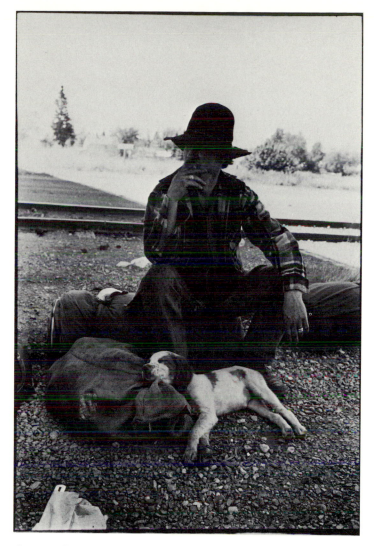

"You see," he explained, "the oldtimer's gone. The *good* tramp, the *real* tramp, he's dead. Now it's the young fellow taking over. They rob, steal—the oldtimer made about a division a day, if he wanted to. Sometimes not even that. He'd stay there a week—maybe ten days—and he'd make his own camp and it'd be clean. There'd be a mirror in the tree hanging up, maybe a frying pan all clean, pots and pans all clean, and wood for the fire. And you left it the same way. Guys don't do that no more today. Punch a hole in the pan, or take it along. Or throw it away.

"Things been changing in the past 15, maybe 20 years. Now most of them get their food stamps and they eat right out of the can. Don't even cook up proper any more. I know where all of them are, on this route especially.

"They got a different philosophy of life, you know, those old 'boes. They were really a throwback, something like a mountain man. They can go out with nothin' and make a living. Just the clothes on their back. Most people can't do that. They'd freeze to death, or starve, but some of us go three, four, or even five days without eating. And think nothin' about it. We get angry too easily, but we're a different breed. Did you ever read about the people that explored? Like Lewis and Clark? The mountain men, that's what I think this tramp is about. We're a generation too late. If you gave us a long rifle, a pair of buckskins and a pair of moccasins 100 or 150 years ago, we'd be right at home. Not the heroes, don't get me wrong. Just the explorers. Go out by ourself all winter long, live with a squaw maybe, and trap and hunt. Then we'd be in our element. Because we can make do and make things on our own.

"There's a lot of tricks on this road, but only a few important ones. You have to learn to stay away from the rest. Set up camp after dark. I never let anybody know where I'm goin'—I wait until the campfire's out and then I disappear. I don't want nobody to follow me!" Then he looked me straight in the eye. "Some people on this road are helpless. When you start helpin' it's just like having a son—they don't know where it stops! You got to support

them—take care of them—you got to provide the hand and I won't do that. If a fella is on this road and he can't learn—then to hell with him!

"Don't travel alone if you can help it—but when you get your job, don't depend on nobody else. If you want to leave, then leave! That's it—a lot of these guys say, 'If you quit, let me know and I'll quit with you.' I say *bullshit.* Before you know it you'll have run out of places to work."

The water began to boil. Carl moved it to the unheated side of the grill, grasping the lip of the can between a wadded-up matchbook cover. He dug through his pack, found a rusty razor, a bar of soap and an unbroken mirror. Soon he had a heavy lather on his face. He scratched and hacked away at his beard until his face was clean. "I'll bet you hardly recognize me! When I'm cleaned up I'm a different man!

"Here—you shave," he commanded, "or you go up the river alone. Ain't no excuse to look like hell when we got hot water and soap." I washed my face in the same water, lathered with the tramp's soap and shaved. I couldn't believe how good it felt to wash only three days dirt away. The tramp seemed to read my mind. "It's good to wash up," he said softly. "It's been longer for me than for you." He dumped the water and put the shaving gear away.

We opened a can of beans and found the bread in the bottom of the pack. The tramp asked me if I'd like to have my bread toasted, then fashioned a holder out of a green branch, bending it back on itself just beyond a fork. The bread held firmly and the green branch did not burn. The tramp toasted four slices, browning both sides, before his holder finally gave away.

The Ride

The train left Laurel and crawled slowly toward Helena. We rode in an oversized boxcar and standing before the 12 by 20 foot door was like standing on a chair in the second row of a wide screen movie. But the ride was slow and gentle and half of the sky was laced in the purple and pink of a prairie sunset. The tramp stood by me and pointed out camps and jungles where he'd stayed at one time or another during the past 25 years, and places where he said the trout were so thick they'd jump right out of the water into your frying pan. The signs of hobo habitation would have gone unnoticed—a bit of refuse around an old fire, usually under a bridge, or even just some matted grass and some old cans in a pile. Back behind a bridge was a shack made from tarpaper and crates, and as we passed, an old 'bo stuck his head out and waved. The tramp said he'd stayed in that very same shack, with different *tarpaper,* but still the same *shack,* seven years before while he waited for a job on a ranch.

The tramp softened up as he told me stories over the noise of the slow-moving train. I mostly kept quiet, trying to decide if I was glad to be in the company of a man I had little reason to trust. When darkness fell, I became too tired to consider the matter further and I fell asleep hoping to wake with my gear by my side.

Sometime in the night I woke again; the train had stopped. When my eyes adjusted to the dark I saw the tramp, perched by the door keeping watch. He told me we were in Helena and that he'd already left to find out if our train was staying together and moving further west. I tried to stay awake but kept falling asleep. After short periods I would wake, startled by dreams, to find the tramp by the door, keeping watch.

By sunrise, four through-freights had passed our train. Finally, when the sun was still low in the sky, the power we had been waiting for idled into position. There were two engines, magnificently powerful even with their strength bound up in slow, rhythmic throbbing. The engines were jockeyed into the middle of the train and we were off once more.

For an entire morning the train pulled up the Rockies. Even with the six engines wide open the freight often slowed to 10 or 15 miles an hour. The smell of pines filled the car and the mountains stretched out below. I stayed by the door and watched while the tramp sat, lost in his own world. Near noon we pulled onto a siding on the top of the mountain, left the extra power behind and raced down into Missoula, where we were switched off the main line and onto a siding. Our bull local was at the end of the line.

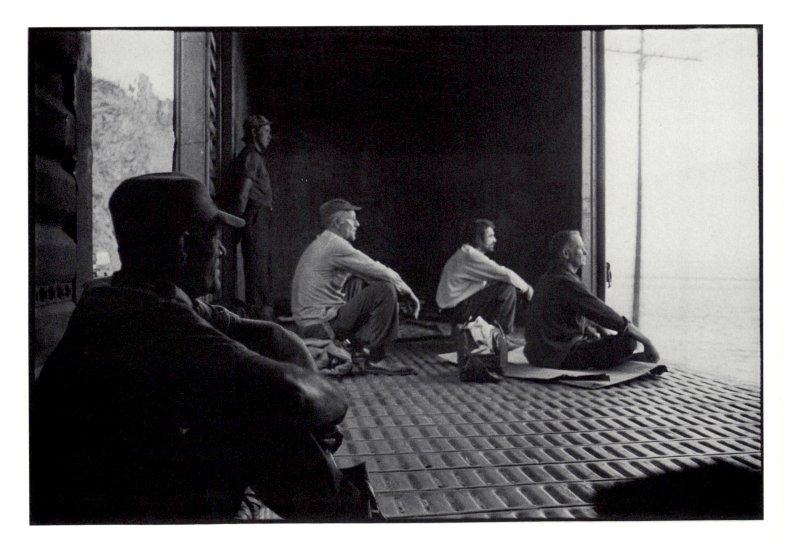

Boston Blackie

"When I'm around a sober man when I'm drunk, I got to go away from that man. And it don't matter how long I knew him or anything. Yesterday mornin' I came down here walkin' on that side of the bridge, and there they were. Three six-packs. 'Oh Blackie, come on over. . . .' One fella came runnin' over carrying three bottles and two dollars for another bottle, 'How's everything, Blackie!' I says, 'What the hell is *this?* You ain't goin' to get Blackie drunk! *I* ain't goin' to get drunk with you!' So with the two dollars—I bought some beans and bread. I could do without going to a fuckin' store to buy their bottle!

"Well, I helped with all the thinnin' and all the proppin'," Blackie continued after a minute, "an' I worked in the summer apples, drivin' tractor—$584 after I paid for all my groceries out of the grocery store. Bars of candy and tobaccee I bought. Lasted three days in Brewster

"Yeah, well, I get so dee-sgusted with myself, I don't know what to do. I can have $100 this mornin' . . ."

Carl interrupted, "An' you won't have a dime tomorrow . . . I know, I know. I'm the same way." Carl nodded at me, "Well, when *you* saw me I was drinking a quart of Grand Canadian, wasn't I?"

"Yeah, that you were."

"That's pitiful," Blackie said seriously, "you ought to be ashamed of yourself. But who's kidding who—it's the same with me." He looked Carl straight in the eye and bent forward to emphasize his point: "Several times lately I found myself wonderin'—just what the hell's going to become of me!"

"There ain't no excitement in it to me anymore," Blackie continued. "Fella was with me last summer, comin' out of Minneapolis . . . and he was worried about the jungles. 'Shit!' I said, 'you don't have to worry about the jungles—main thing to worry about is something to put in the kettles and fryin' pans I'm carryin' here!' We had a bunch of sardines, bread and crackers. We rode along drinkin' water, eatin', and as he was ridin' along he says to me: 'By God, the scenery looks good along the tracks!' 'Full stomach,' I says, layin' my head on the bedroll . . . I knew what was ahead. Next mornin' I'm waitin' to hear what he has to say. We're ridin', and he's standin', lookin', lookin', hands in his pockets, an' scratchin' his head every once in a while. Pretty soon I says: 'You ain't got no sardines, no fuckin' bread, nothin' to drink—how does she look out there now? How she lookin' out there today?' 'Ahhh Blackie,' he says, 'no good!' 'I know,' I says, 'empty gut!'

"Nice to have a little sack of groceries," Blackie added, "makes that scenery look darn nice!"

He turned to me, "Well, I've known that fellow, Carl, a long time and he always gave me a bite when I was hungry . . . a smoke when I was short. And I seen many a one he shared his coffee with. . . ."

"See what I told you?" Carl said to me, "I told you I'd meet somebody . . . always do. . . ."

"Many a drink of wine, many a drinkin' fool," Blackie said, "that's our way of livin' . . . that's the way we got to go along. . . ."

"If he's a tramp, I'll give anything I got," Carl said, "and there's some I won't even say 'Good Morning' to. . . ."

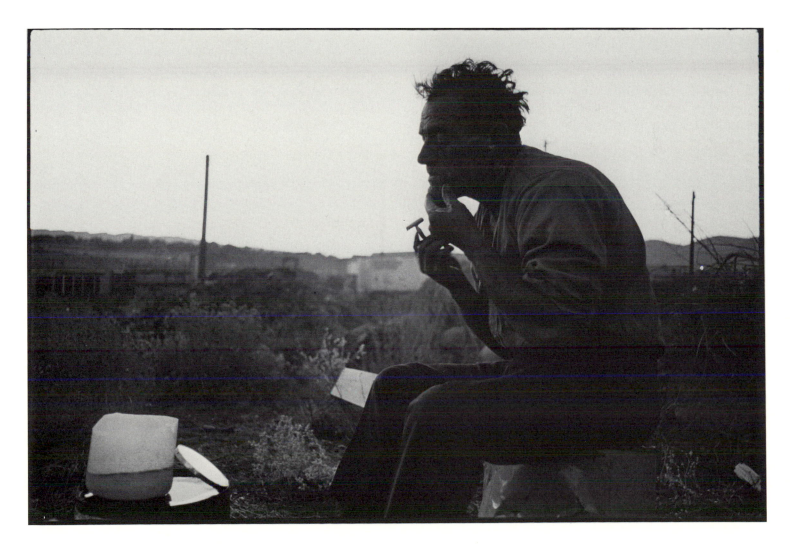

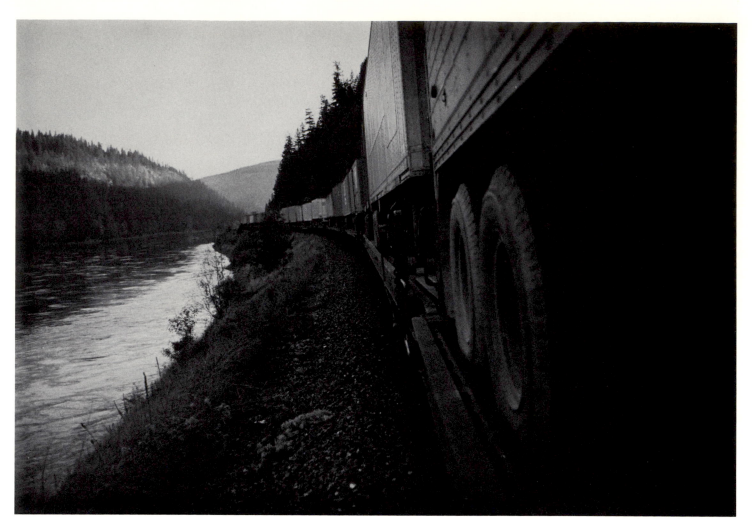

The End of the Road

"It's dyin' out," Carl said, "the new tramps is different. They act different, they look different, and they talk different."

"That may be," I said, "but as long as there is fruit, there will be tramps here to harvest it. And as long as there are trains, there will be people riding . . . so you would think that the lingo wouldn't die out, and that the people would still be *tramps*."

"There will be different guys. And it is going downhill. Now it's a different class of people. And eventually there's not going to be a train you can ride. They're building the cars so you can't ride'em. It's not that they are cracking down in the yards—they'll have cars after awhile where there's no space where you can get in."

"You mean they won't cart empties around?"

"Well, if they do, they close them up! Like that one we couldn't get into. They seal 'em."

"But you can break those seals easy enough. . . ."

"You better not break that seal! You won't go breaking no seals if you know what's good for you. Interstate commerce regulations. You'll really get your ass in trouble if you go fucking around with those seals. See, if one seal is already broken, you're all right. But they're startin' to seal both sides. You can't tell where the empties are. Are you telling me you're going to walk down that train and break seals until you find an empty? I'll stand back and watch—you tell me when you find one!"

"You could always ride a gondola."

"They're covering the gondolas, too. Don't you remember seeing some of those on the tracks?"

"Piggybacks?"

"You know on a piggyback, you only have to have just enough floor space for the wheels of the truck. They're starting to build them without no floor in them . . . you can't ride'em! Just a runway for the truck wheels to go on . . ."

"But what about grain cars?"

"They're building them without floors, too! Just a little framework—no floor at all. *Nobody* can crawl in there and hang on. Maybe for ten miles, but that's it. And if you fall through one of those, you know where you're going, don't you? Under the wheels!

"And those grain cars with the solid steel floor? You get in the back there—that's a damn good ride in the summer, but in the wintertime—you can't do it! Anything steel in the

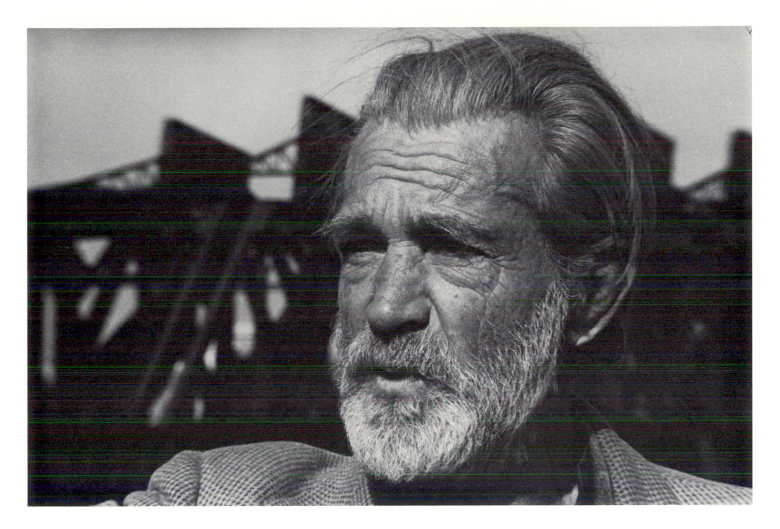

winter—you stay off it . . . unless you can put two or three layers of cardboard between you and the steel, then you might be able to make it. But I've been so cold I couldn't move! Sitting on some steel floor of some boxcar, too cold to move, thinkin' if I don't move, I'll never get up. Christ, that's cold!

"And they're getting faster and faster. Used to be hi-ball meant about 50 miles an hour . . . that was back in the steam days. Now the only thing that's keeping them under 90 is the tracks. When they get around to fixin' the tracks, it'll be all over . . . nobody can ride 'em when they go like that. . . ."

Harvest Jungle

The train pulled out smoothly and we were soon traveling along a beautiful river bank. The tracks were halfway up bare brown hills on the west bank of the river, so the long rays of the sun lit the train intermittently with long slanting rays. For a few moments the sun shone through the doors of the car and the shadows of the tramps stood out like black giants on the opposite bank of the narrow river. The drinkers became quiet and moved to the front of the car and others took their places sitting cross-legged before the doors, staring as if transfixed by the landscape and the river that spun by below.

He rose and stretched. "Well, I don't know about you, but I'm about ready to turn in."

I was about to pour water on the coals of the fire when Carl stopped me: "Are you going to go find more for our coffee tomorrow?" Then he kicked dirt onto the ashes, and picked up the tin can and put it in his pack.

The hills rose steeply behind us and the tracks were perhaps 50 yards in front of the jungle. The orchard lay across

the tracks; beyond flowed the Okanogan River. The lights of the town shone in the distance.

We gathered our belongings and walked wordlessly across the tracks, into the most obscure corner of the orchard. An orange moon had risen and lit our way with an eerie yellow light. I followed Carl to an area where the weeds were higher than our knees, then we worked our way under a tree with a canopy of branches. The branches were heavy with fruit and reached to the ground. It seemed as though we had entered a safe and dark nest.

We cleaned fallen apples off the ground, some larger than my fist, and rolled our sleeping bags out in six inches of lush, soft grass. It was as soft as a feather mattress.

One-Eyed Jack

''. . . I seen a fella yesterday, hell, he was on the job five weeks, and when he got through with his trip to the tavern he didn't have nothin' but a few cents change in his pockets. You might have seen him in the yards. He had a little yeller cap on. Big red-faced guy and a little-bitty yeller fucked-up cap. He and I jungled together back in Spokane for awhile. I didn't ask him to get off that train up here, I figure that's something a man has got to work out for himself! But he jumped and we was heading down to this jungle I know and he says, 'It's too far to walk.' Well, shit, there ain't nobody goin' to tell me what to do or where to get off— so I went down and jungled by myself. So I don't share my beans this time. And with what I got in that jar I can make three days. It might be a slim get-by, but I can do it . . . but how are you going to get by these days? Potatoes, *potatoes* are 20 some cents a pound. What a bunch of bullshit! I can eat that old macaroni. Macaroni ain't no cheaper, but I can get two meals out of a pound. I can't do that with potatoes. When I start eatin' a pound of potatoes I just got to finish! Restaurant's the same. Goin' out of sight. I know damn well you know what I'm talking about when I say *spare*ribs. You get a little salad, a few french fries, and your spareribs. Two dollars and a half. If you want to call that a cheap meal— well, I don't see nothing cheap about a bunch of old bones— very little meat on those spareribs, any fool knows that! Two and a half for a meal? Why, suck my butt! If I was a millionaire I wouldn't buy that kind of junk! I'd put in another half buck, or six bits and buy myself a roast beef dinner. It's two and a half, I'd put another dollar on it and make it three and a half and help myself to some good meat!'' He paused, and then said: ''When I'm workin' it strikes me different. If I'm workin'— *fuck* the goddamned money. I'm going to buy the food! I'll walk in that store and see a piece of meat— if it costs two dollars and six bits to keep my gut full, that's part of my livin'. I'm only on this world for a short time, and I'm damn sure if I got this money in my pocket— if I'm workin'— I'll eat. Now I can get along on this other kind of grub— this old hard grub when I'm not workin'. Like I'm eating today. Macaroni and beans, shit like that. And I'll eat a little of that, too, when I get myself situated. But I won't eat too much of it once I get going. Now, some of these people start whining: 'Oh, I'll wait till I get. . . .' 'I say, *damn* down the road. Damn down the road. Shit, *fuck* that down the road! You're liable to go to a bank, get that son-of-a-bitch cashed and somebody's liable to waylay you— knock you on the head before you even get on the train! Lose every dime. And there's no lookin' back then, at all the good eatin' you did off that money. So I ain't goin' to wait till I get on the road. I'm goin' to eat that son-of-a-bitch up— part of it, anyway— while I'm workin'. . . .'' ◇

Bibliography

Works by Photographers Represented in the Exhibition

Berger, Charles. *Image Tibet.* Mill Valley, California: Artisan Press, 1973.

———. *Flamenco Gitano.* Mill Valley, California: Artisan Press, 1974.

Cancian, Frank. *Another Place: Photographs of a Mayan Community.* San Francisco: Scrimshaw Press, 1974.

———. *Change and Uncertainty in a Peasant Economy: The Maya Corn Farmers of Zinacantan.* Stanford, California: Stanford University Press, 1972.

———. *Economics and Prestige in a Maya Community: The Religious Cargo System in Zinacantan.* Stanford, California: Stanford University Press, 1965.

Collier, John, Jr., and Buitron, A. *The Awakening Valley.* Chicago: University of Chicago Press, 1949.

Duff, Euan. *How We Are.* Baltimore: Penguin Press, 1971.

———, and Marsden, Dennis. *Workless.* Baltimore: Penguin Press, 1975.

Gardner, Robert, and Heider, Karl G. *Gardens of War: Life and Death in the New Guinea Stone Age.* New York: Random House, 1968.

Harper, Douglas A. *Good Company.* Chicago: University of Chicago Press, 1982.

Heider, Karl G. *Ethnographic Film.* Austin: University of Texas Press, 1976.

Horwitz, Richard P. *Anthropology Toward History: Culture and Work in a Nineteenth Century Maine Town.* Middletown, Connecticut: Wesleyan University Press, 1978.

Jackson, Bruce. *Killing Time: Life in the Arkansas Penitentiary.* Ithaca: Cornell University Press, 1977.

Ohrn, Karin Becker. *Dorothea Lange and the Documentary Tradition.* Baton Rouge: Louisiana State University Press, 1980.

Rosenberg, Mark L., MD. *Patients: The Experience of Illness.* Philadelphia: The Saunders Press, 1980.

Viveiros de Castro, Eduardo. "Alguns Aspectos do Pensamento Yawalipíti (Alto Xingu): Classificacões e Transformacões." *Boletim do Museu Nacional, Antropologia* 26 (1978).

The Photographic Exploration of Society

Becker, Howard S. "Aesthetics and Truth." *Society,* July 1980, pp. 26–28.

———. "Do Photographs Tell the Truth?" *Afterimage,* no. 5, February, 1978, pp. 9–13.

———. "Photography and Sociology." *Studies in the Anthropology of Visual Communication,* no. 1 (1974), pp. 3–26.

Byers, Paul. "Cameras Don't Take Pictures." *Columbia University Forum,* no. 9 (1966), pp. 27–31.

Collier, John, Jr. *Visual Anthropology.* New York: Holt, Rinehart and Winston, 1967.

Hocking, Paul, ed. *Principles of Visual Anthropology.* The Hague: Mouton, 1975.

Mead, Margaret, and Bateson, Gregory. "For God's Sake, Margaret." *Co-Evolution Quarterly,* no. 10, June, 1976, pp. 32–44.

Ruby, Jay. "In a Pic's Eye: Interpretive Strategies for Deriving Significance and Meaning from Photographs." *Afterimage,* no. 3 (1976), pp. 5–7.

Sekula, Allen. "On the Invention of Photographic Meaning." *Artforum,* no. 13, January, 1975, pp. 36–45.

Wagner, Jon, ed. *Images of Information: Still Photography in the Social Sciences.* Beverly Hills, California: Sage Publications, 1979.

Some Exemplary Works of Photographic Social Exploration

Banish, Roslyn. *City Families.* Chicago: Pantheon, 1976.

Berger, John, and Mohr, Jean. *A Seventh Man: Migrant Workers in Europe.* New York: Viking Press, 1975.

Brassai. *The Secret Paris of the Thirties.* Chicago: Pantheon, 1976.

Frank, Robert. *The Americans.* New York: Grossman, 1969.

Freedman, Jill. *Circus Days.* New York: Harmony Books, 1975.

Heyman, Abigail. *Growing Up Female: A Personal Photojournal.* New York: Holt, Rinehart and Winston, 1974.

Lyon, Danny. *The Bikeriders.* New York: MacMillan, 1968.

Meisalas, Susan. *Carnival Strippers.* New York: Farrar, Straus and Giroux, 1976.

Owens, Bill. *Suburbia.* San Francisco: Straight Arrow Press, 1973.

Smith, W. Eugene, and Smith, Aileen M. *Minamata.* New York: Holt, Rinehart and Winston, 1975.

Cover: White Dull Cameo, cover basis 100.

Body: White Dull Cameo Enamel, text basis 80.

End paper: Artlaid II, text basis 80, rust.

Typography: Optima Bold and Medium, Roman and Italic.

Printing: Offset Lithography.

9254